NORTH CAROLINA
unforgettable

PHOTOGRAPHY BY
ROBB HELFRICK

FARCOUNTRY
PRESS

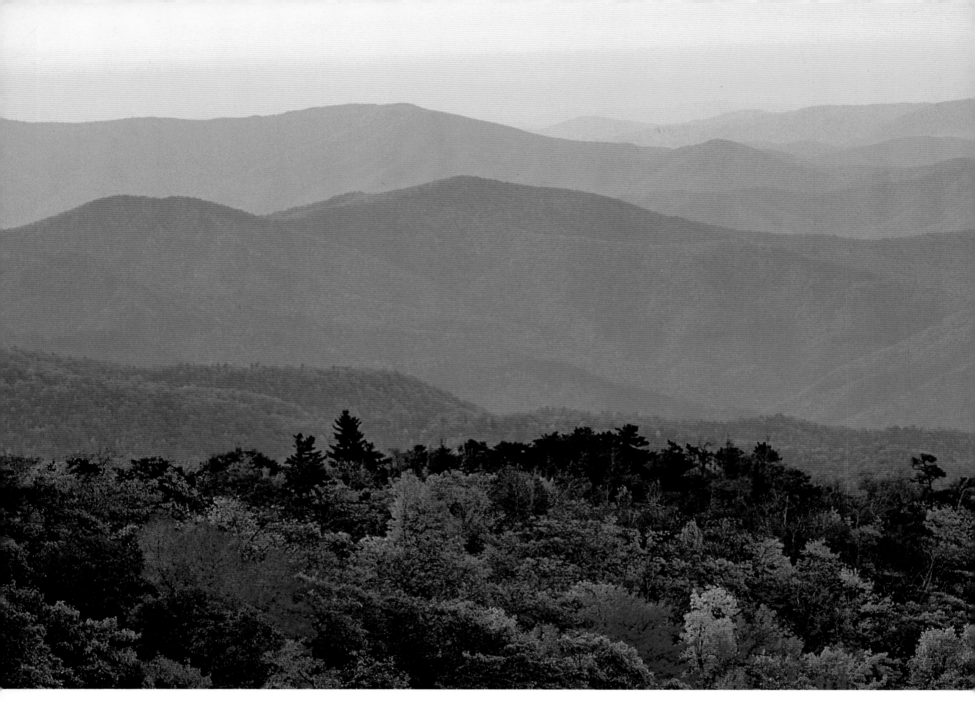

Above: Early light warms an autumn landscape, seen from the lofty heights of the Blue Ridge Parkway near Grandfather Mountain.

Facing page: On the southern coast at daybreak, a great egret wades through the shallow waters of the marsh on Harkers Island.

Title page: Rhododendrons, mountain laurels, and azaleas take turns brightening Blue Ridge mountainsides throughout the summer.

For Andrew, a kind man and a wonderful brother.

ISBN 10: 1-56037-619-8 (Upper Whitewater Falls cover)
ISBN 13: 978-1-56037-619-4 (Upper Whitewater Falls cover)
ISBN 10: 1-56037-610-4 (Cape Hatteras Lighthouse cover)
ISBN 13: 978-1-56037-610-1 (Cape Hatteras Lighthouse cover)

© 2014 by Farcountry Press
Photography © 2014 by Robb Helfrick

For more information about our books, write Farcountry Press, P.O. Box 5630, Helena, MT 59604; call (800) 821-3874; or visit www.farcountrypress.com.

Produced in the United States of America.
Printed in China.

18 17 16 15 14 1 2 3 4 5 6

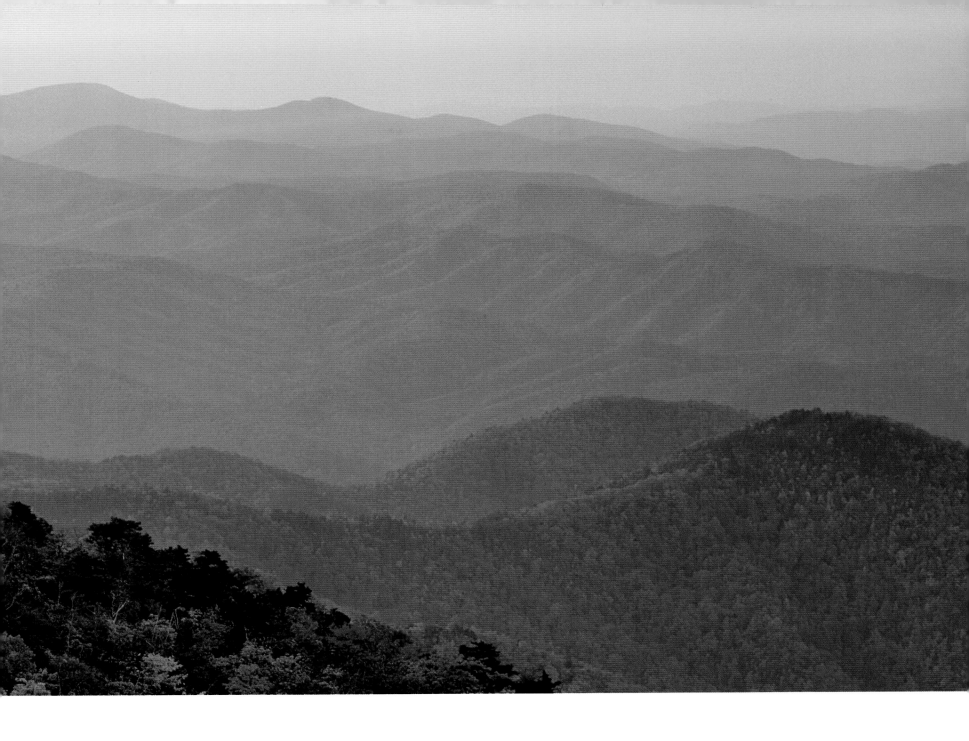

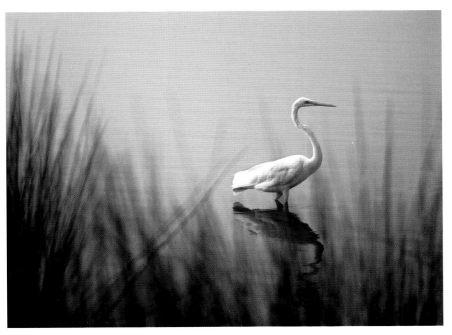

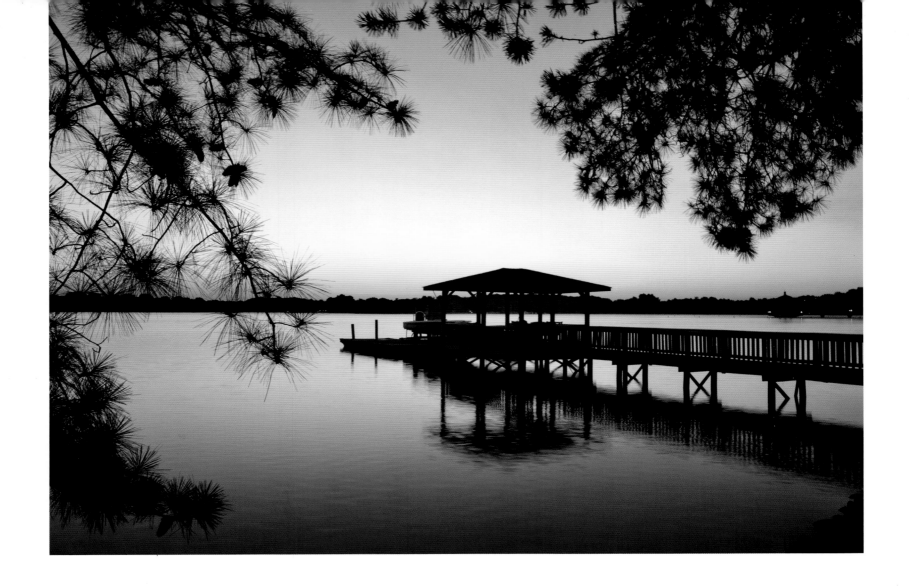

FOREWORD *by Robb Helfrick*

FROM THE SHALLOW SHOALS OF THE OUTER BANKS TO THE ancient peaks of the Appalachians, North Carolina offers an infinite variety of experiences and sensations. With an understated grace, the state has managed to hold on to the simple traditions of the past without sacrificing the promise and progress of the future. It is this balance between humankind and nature and between past and present that makes North Carolina truly special.

In the last hundred years, residents and visitors alike have come to cherish the beauty and relaxation found in scenic North Carolina. It isn't difficult to understand why the landscapes here evoke such strong emotions. Long before modern humans could conceive of a place called Carolina, ancient forces were shaping the land. In the east, rising and falling sea levels, along with prevailing winds, tides, and hurricanes, helped to create a unique ecosystem. A string of peninsulas and barrier islands, now known as the Outer Banks, formed along the North Carolina coast. This sandy strand covers almost the entire shoreline of the state and separates

Currituck, Albemarle, and Pamlico Sounds from the Atlantic Ocean. It is a dynamic and unforgiving territory, known not only for its ever-changing scenery, but also for the dangerous currents that threaten mariners and their sailing vessels. Since the currents claimed their first recorded victims in 1585, there have been more than 1,000 documented shipwrecks in this area, known famously as the "Graveyard of the Atlantic."

The remnants of earlier seafaring times are still evident along the seashore. Navigation is much safer these days, but lighthouses from earlier times—some still in operation to protect modern seafarers—are sprinkled along the coastline. The most famous of these, the candy-striped Cape Hatteras Lighthouse, was moved inland in 1999 to escape the encroaching surf, and it remains one of the most iconic landmarks in North Carolina. Tough and sturdy wild horses, the descendants of horses brought to the New World by Spanish explorers, roam the beaches in several Outer Banks locales. The massive sand dunes still present on the coast not only provided altitude and steady wind for Orville and

Wilbur Wright's first successful flight, but today also give the needed lift for modern-day adventurers who hang glide at Jockey's Ridge State Park. Always, though, a hint of the untamed makes itself known. Wildlife is abundant here in this coastal sanctuary, often seen while boating in the marsh or during a stroll on the beach.

Traveling west from the coastal plain, the Piedmont appears with its rolling hills and thriving towns. This is where the majority of North Carolina's citizens live and work, and the area impresses with its steadfastness and determination. Gold was discovered in the region by twelve-year-old Conrad Reed in 1799, the first such find in the United States. In Durham and Winston-Salem, the spires of historic chapels rise above the trees. Red clapboard houses catch the eye in historic Old Salem. The day-to-day workings of state government press onward in Raleigh as visitors experience a variety of first class museums. In Charlotte, gleaming skyscrapers light up the downtown skyline. The Piedmont is the geographic heart and engine of North Carolina.

Beyond and above the Piedmont, the Appalachian Mountains come into view. Their lush forests and sheltered coves are filled with roaming black bears and cascading waterfalls. The roof of North Carolina is found at Mount Mitchell at 6,684 feet, the tallest point in the eastern United States. Connecting a great part of this lofty territory is the Blue Ridge Parkway, the scenic roadway revered as "America's Favorite Drive." The parkway twists and turns through tunnels and past overlooks until it reaches the entrance to Great Smoky Mountains National Park. World famous for its plant and animal diversity, the park is home to over 1,000 species of wildflowers and more varieties of trees than are found in all of Europe. Northern and southern species coexist here, so a trip up a mountain can be the botanical equivalent to a journey from North Carolina to Canada. In the Cataloochee and Oconoluftee areas of the park, the spirit of the early mountain pioneers' simple life endures.

There are many wonderful communities in the mountains that offer relaxation and natural delights. Asheville is the epitome of hospitality, with its fine restaurants and galleries alongside the iconic landmarks of Biltmore Estate and the Grove Park Inn. Charming towns like Blowing Rock, Highlands, and Waynesville keep visitors coming back with their idyllic small-town environments. The forests that surround these towns are best appreciated at the peak of the autumn season. The senses are overwhelmed with the fiery reds of maples and sourwood trees, mixed with the yellows and oranges of other deciduous trees in nature's annual vibrant display. Fog often obscures the mountains in these parts, creating ghostly shapes and concealing ridges and peaks for hours or sometimes only a few short seconds. Just out of town, a glimpse from a high overlook reveals distant mountains with names like Grandfather or Pisgah rising above an undulating carpet of trees that hides any evidence of man's existence.

Random lines drawn on a map hundreds of years ago do not define the gracious state of North Carolina. It has evolved to become the special place that it is today through a more organic process. Ancient forces have left behind a natural landscape that is diverse and dynamic. From America's oldest mountain range to the cultured plains to a legendary coastline, it is a land that changes from season to season and year to year, and the proud people of North Carolina, with their welcoming nature and boundless pride, have learned to live in harmony with this ever-changing land. This perfect balance underscores North Carolinians' belief that there are only two types of people—those who live in the Tar Heel State, and those who hope to one day call it home.

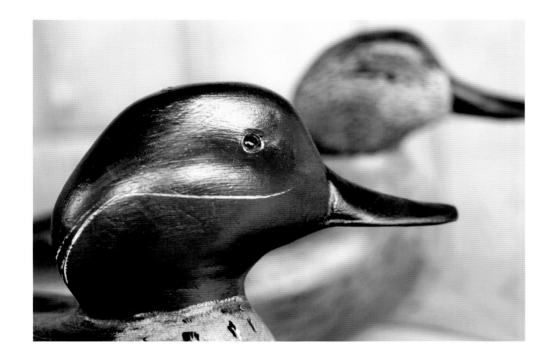

Left: Collectors and hunters alike prize hand-crafted duck decoys from the carvers of the Outer Banks.

Facing page: A still morning on the shore of Lake Norman is a serene beginning to a summer day spent on the water. The lake is a popular year-round destination for Charlotte-area residents.

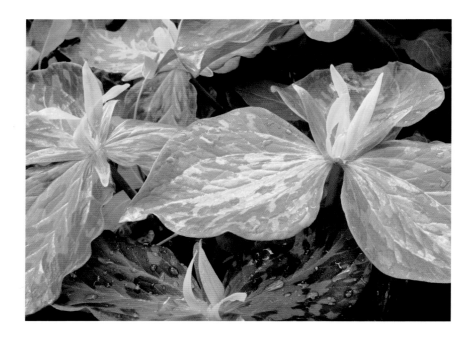

Above: Yellow trilliums carpet the springtime forest floor, usually in the shade of mature hardwoods.

Right: Mingus Mill, a water-powered turbine gristmill built in 1886, is still in operation today. The mill is a popular stop for visitors in Great Smoky Mountains National Park.

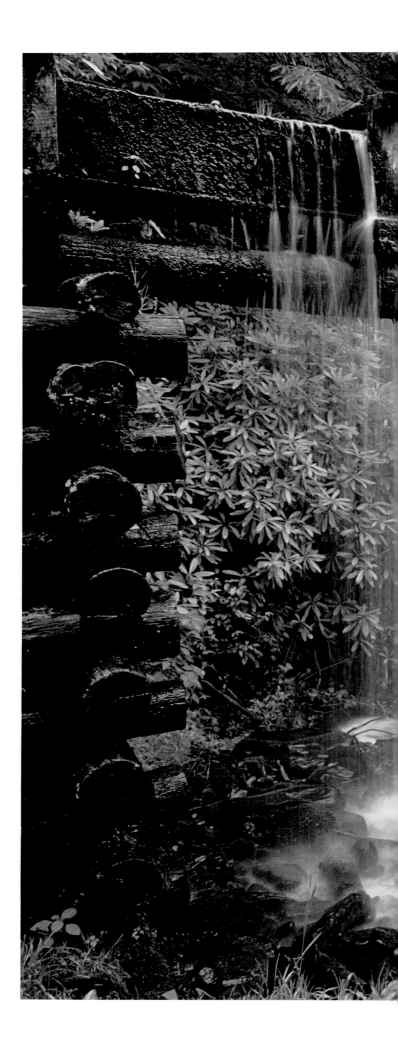

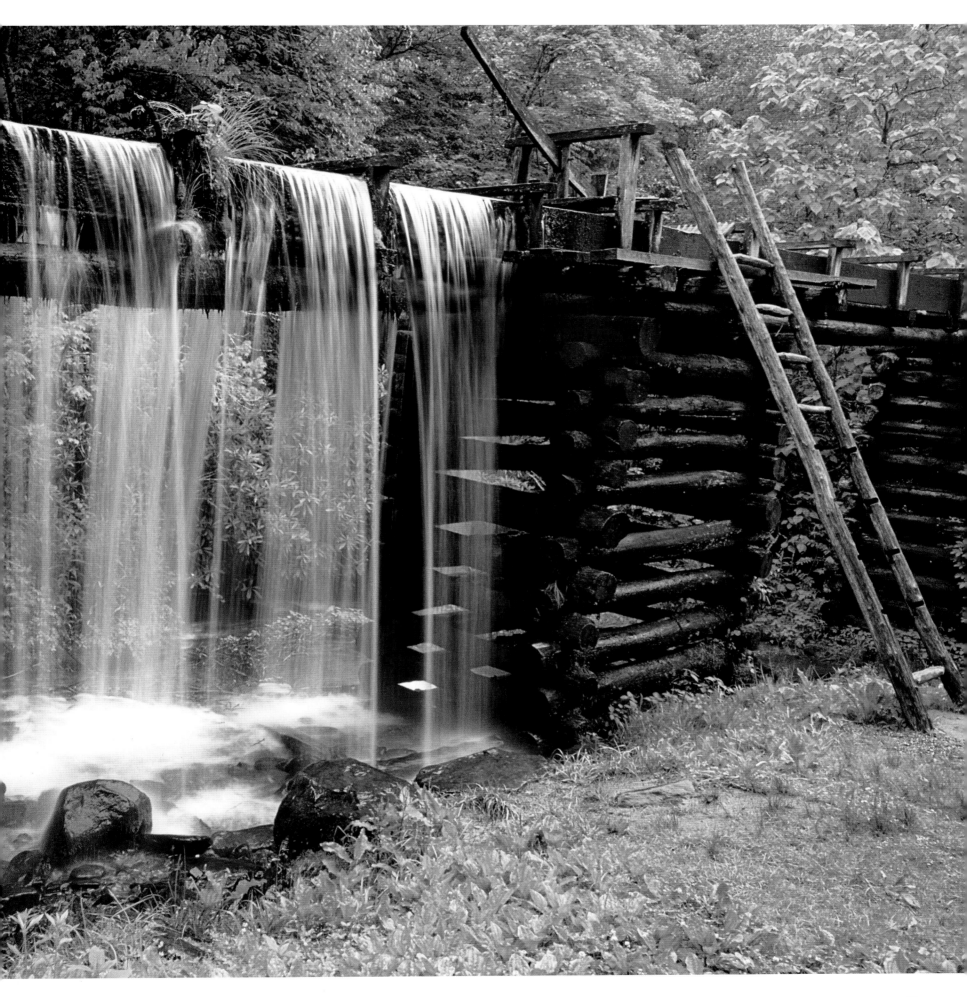

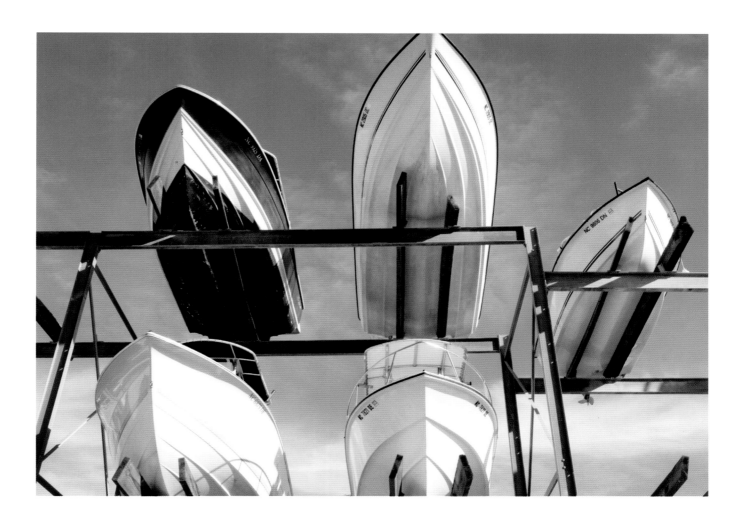

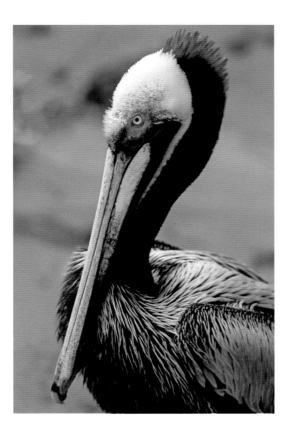

Above: These dry-docked watercraft in Southport are immune to any sudden shift in the weather while they await the next adventure with their owners or renters.

Left: Brown pelicans are a common sight in villages all along the North Carolina coast.

Far left: A shoal, a sandbar or shallow area, near Cape Hatteras is clearly visible from above shimmering blue waters. In the peak of the summer season, the water reaches a very comfortable temperature of eighty degrees.

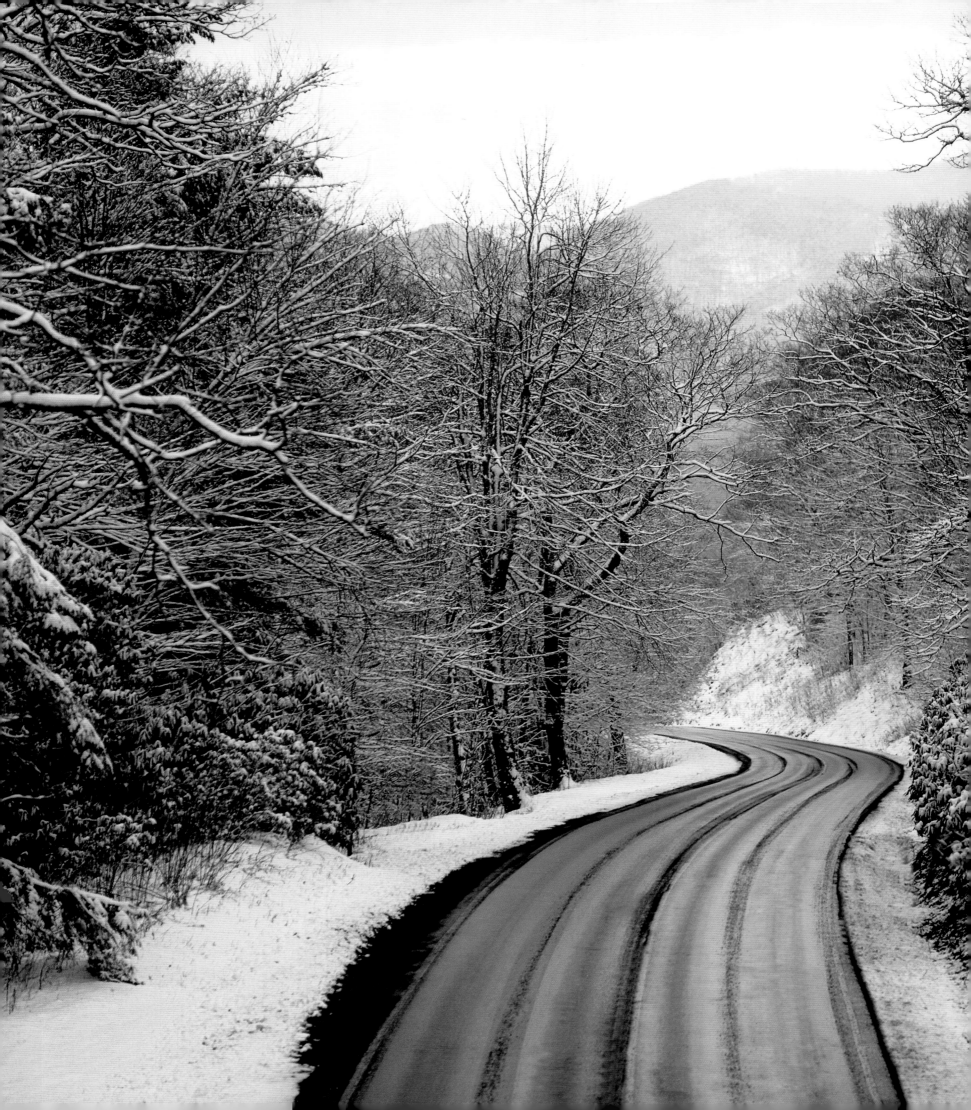

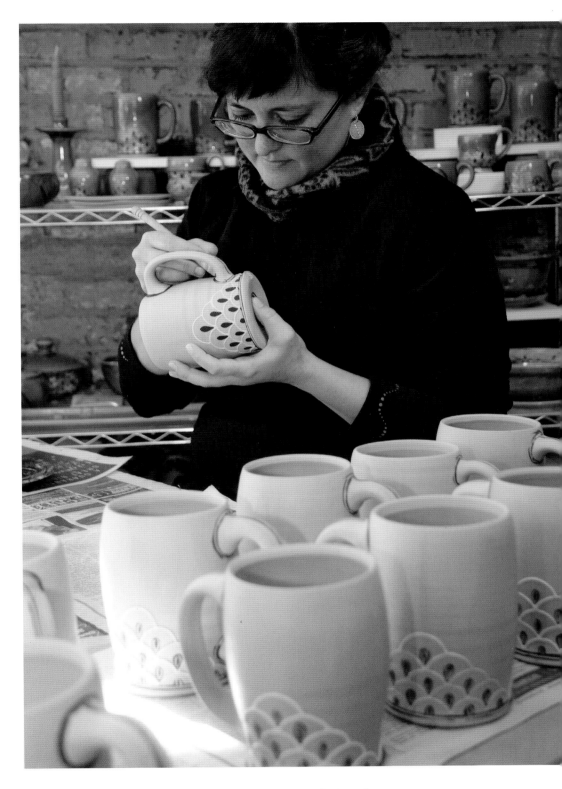

Above: A potter puts the finishing touches on her handcrafted work in the River Arts District in Asheville.

Left: A January snowfall paints a wintery picture on Highway 19 in Soco Gap, just above the mountain town of Maggie Valley.

At this downtown Greensboro lunch counter in 1960, four African-American students began a nonviolent sit-in to protest segregation. Their bravery was instrumental in the advancement of civil rights in the South. The original Woolworth store where it all began is now home to the International Civil Rights Center and Museum, devoted to the ongoing struggle for civil and human rights.

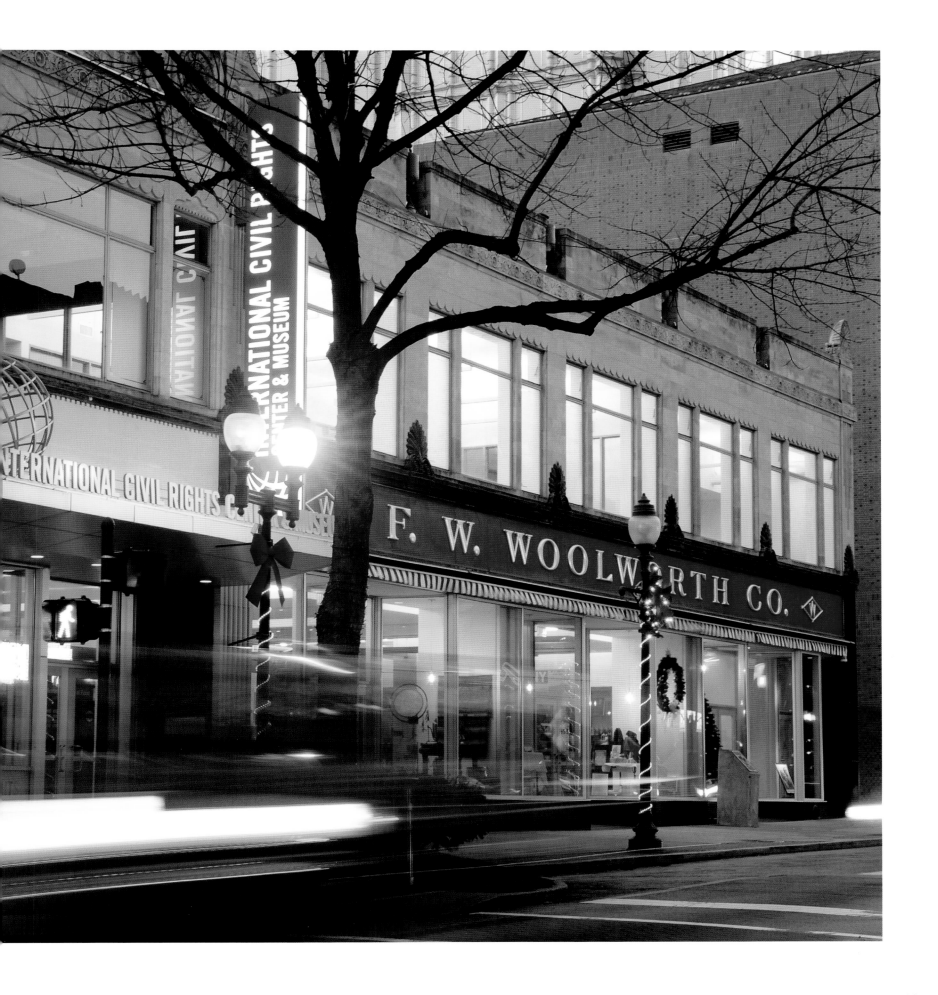

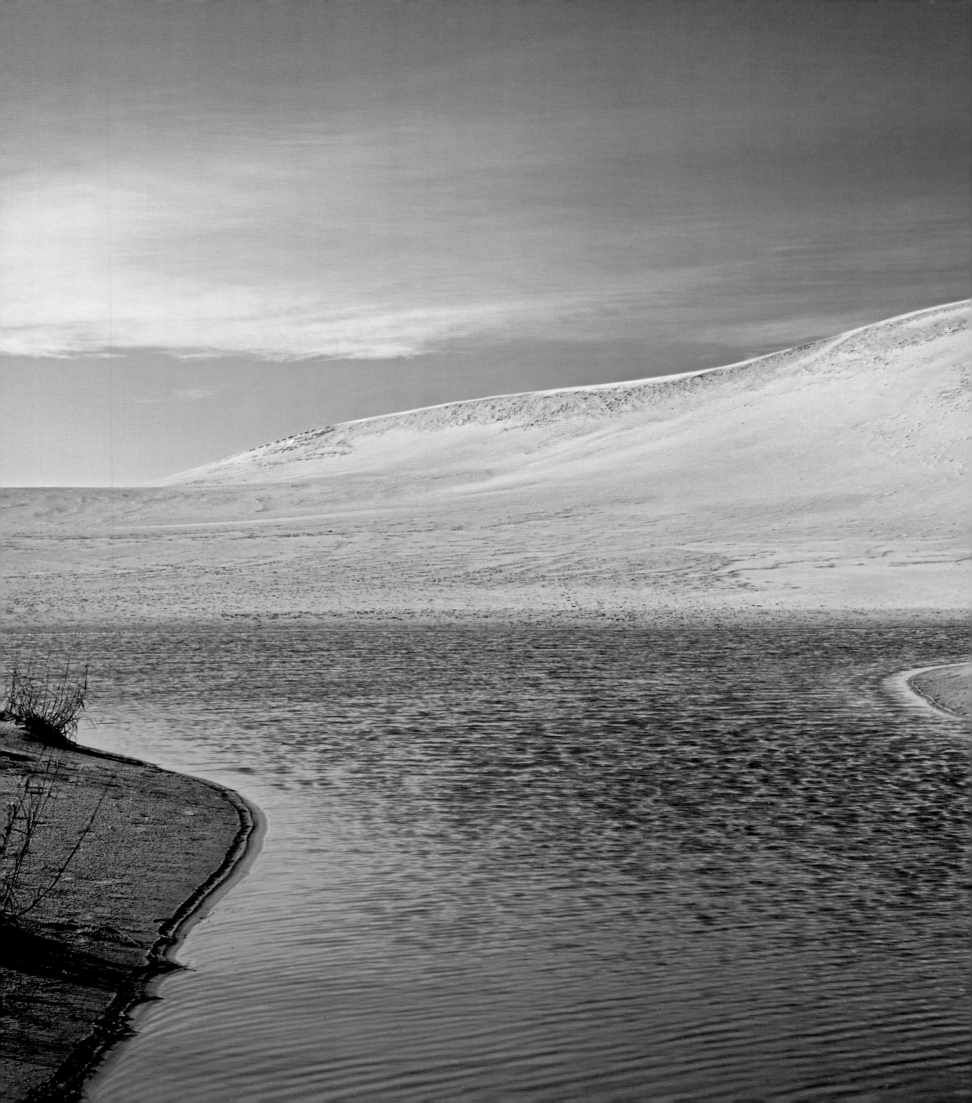

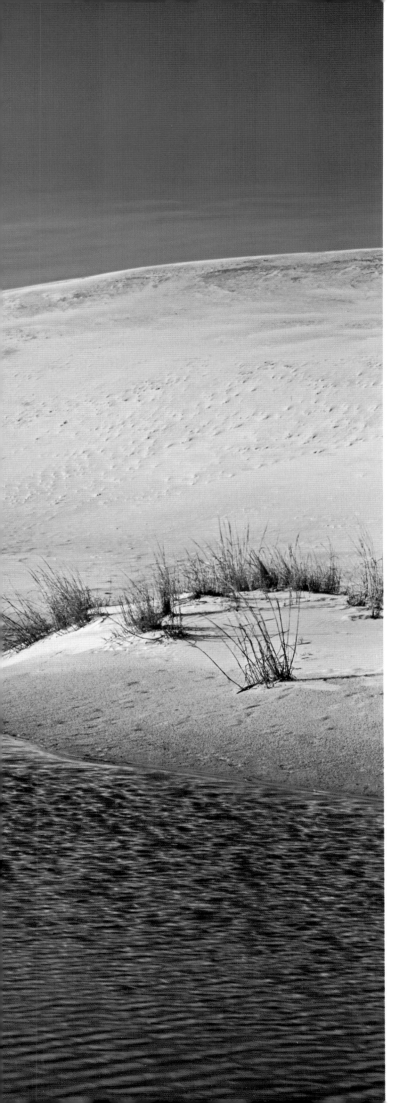

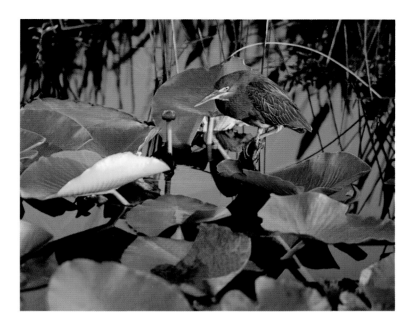

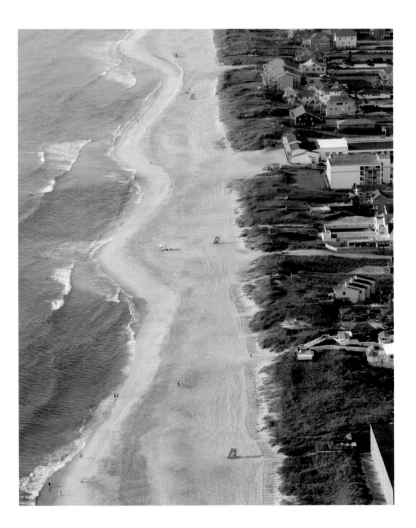

Above, top: A small green heron perches among lily pads at the fringe of a Carolina pond.

Above, bottom: A morning view along the Nags Head shore finds beach walkers already out for their morning stroll.

Left: Found on the edge of Roanoke Sound, the ever-changing sands of Jockey's Ridge State Park constitute the tallest natural dune system in the eastern United States.

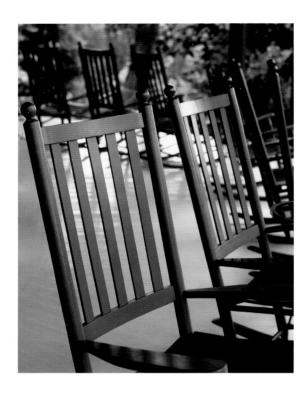

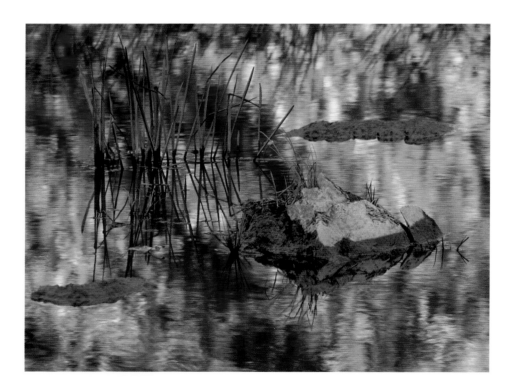

Above, top: Rocking chairs on an Asheville porch are an invitation to relax and unwind in the mountains.

Above, bottom: Red fall foliage reflects in the shaded waters of the Nantahala River. The river's name is taken from the Cherokee phrase for "Land of the Noonday Sun," and its gorge is a popular playground for whitewater rafters and boaters.

Right: Seen through a stand of bamboo, a vibrant footbridge spans tranquil waters at Sarah P. Duke Gardens in Durham.

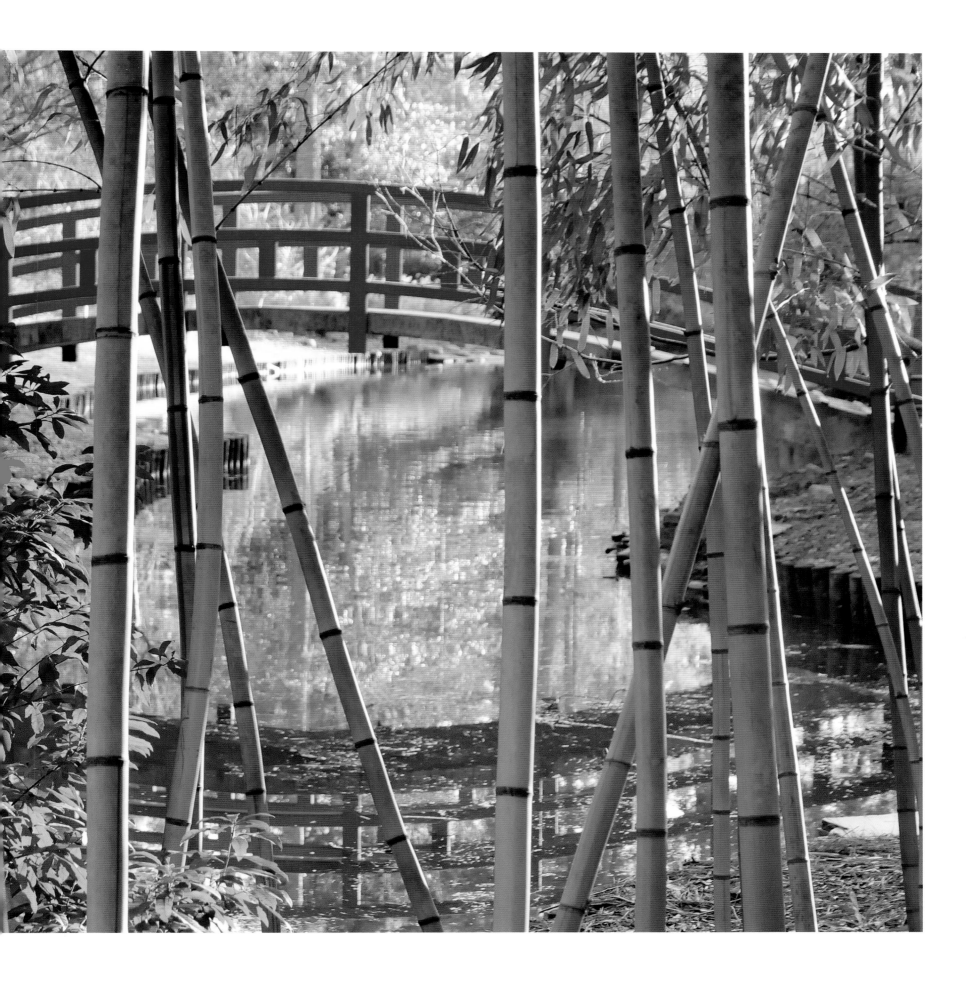

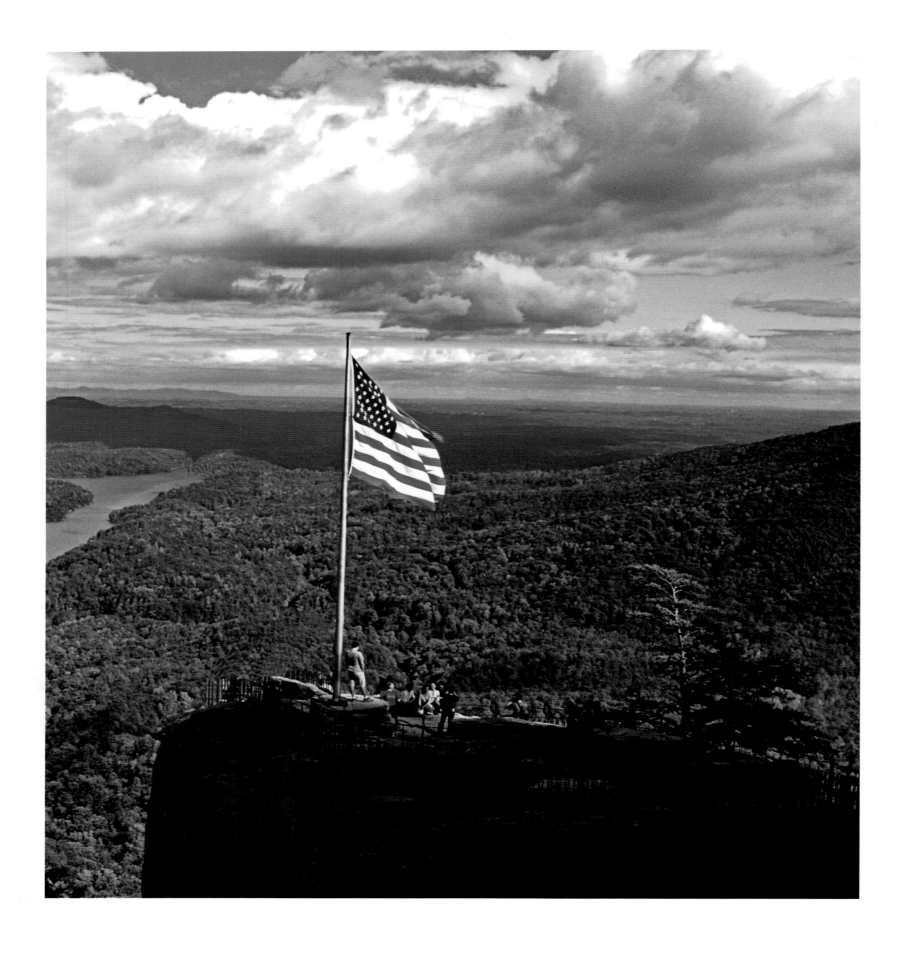

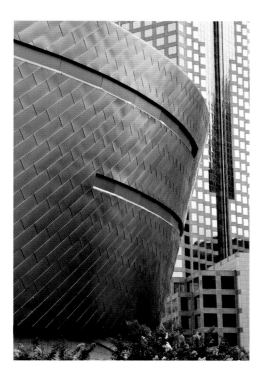

Facing page: On a breezy summer day, the flag flies proudly atop Chimney Rock, a granite monolith with spectacular views of the countryside surrounding Chimney Rock State Park.

Left: The stainless steel exterior of the NASCAR Hall of Fame in Charlotte evokes the sensation of a roadway racing around the perimeter of the building.

Below: Inside the NASCAR Hall of Fame, life-size stock cars line up on the racetrack and appear ready to roar. The Hall, opened in 2010, honors past and current greats from the world of stock car racing and educates fans about this high-octane sport.

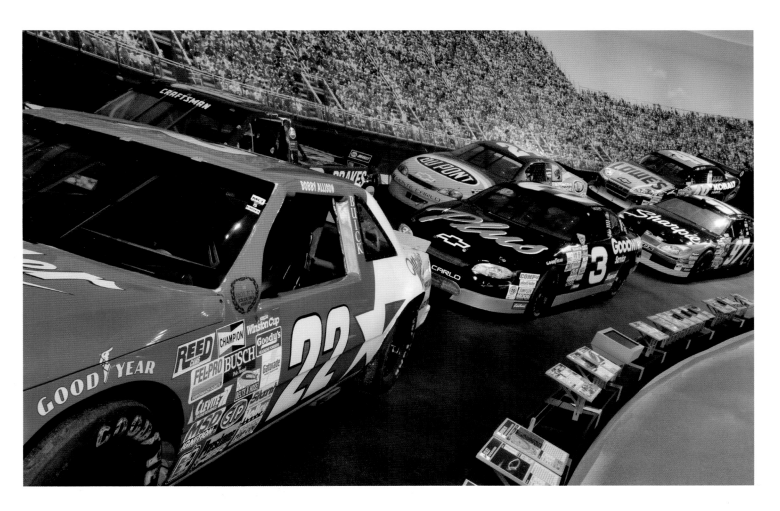

Right: The distinctive, candy-striped Cape Hatteras Lighthouse was moved inland to its present location in 1999 to escape the dangers of the encroaching surf. It remains one of the most recognized symbols in the state of North Carolina. At 198.5 feet, it is the tallest brick lighthouse in the United States.

Below: Atlantic blue crabs are a prized but short-lived delicacy as "soft-shell crabs" when they molt their hard outer shells in early summer.

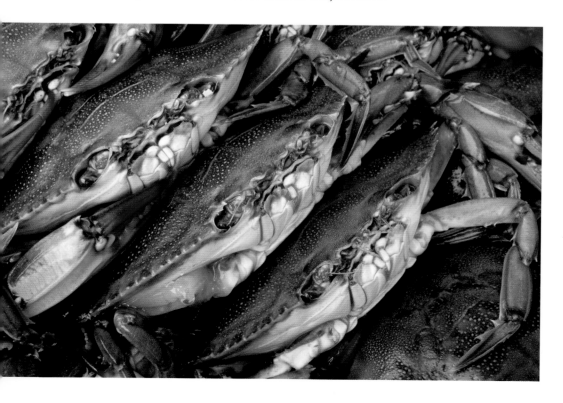

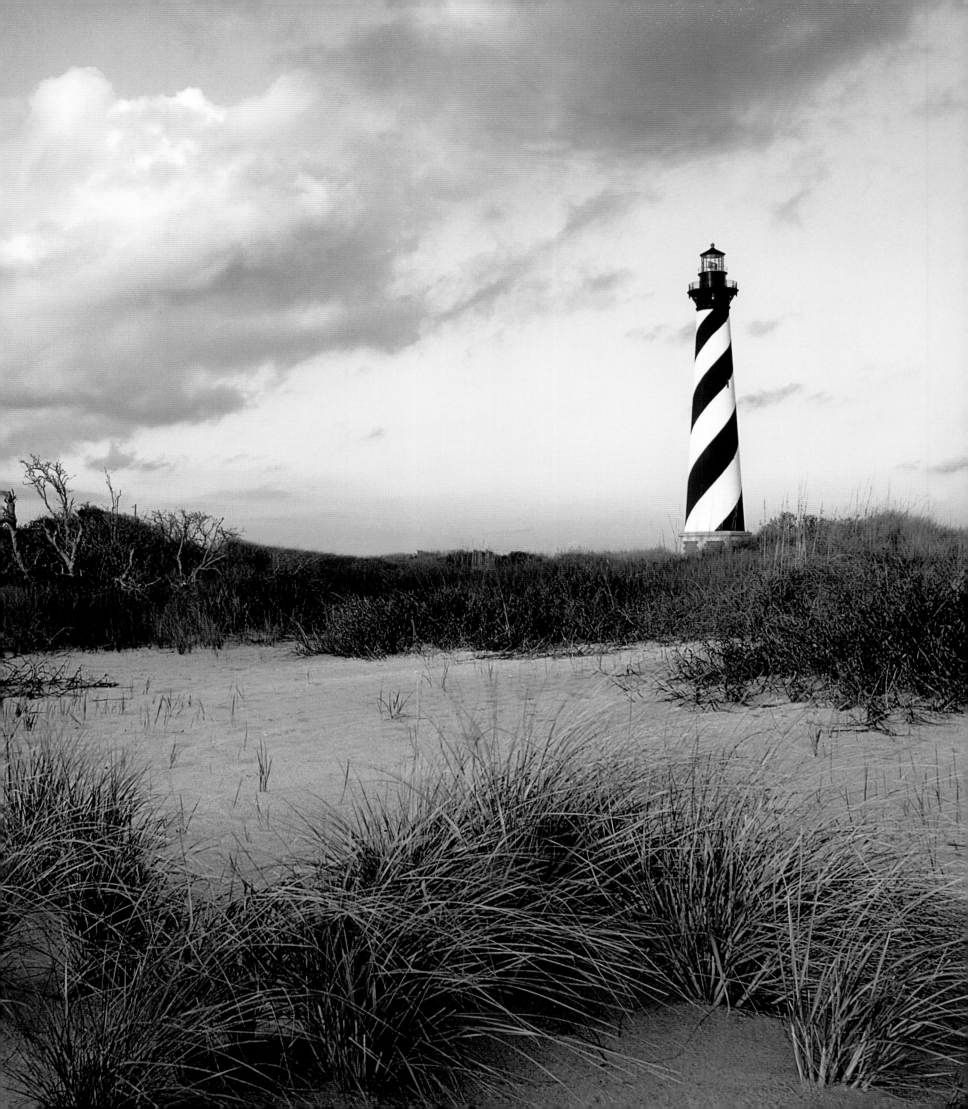

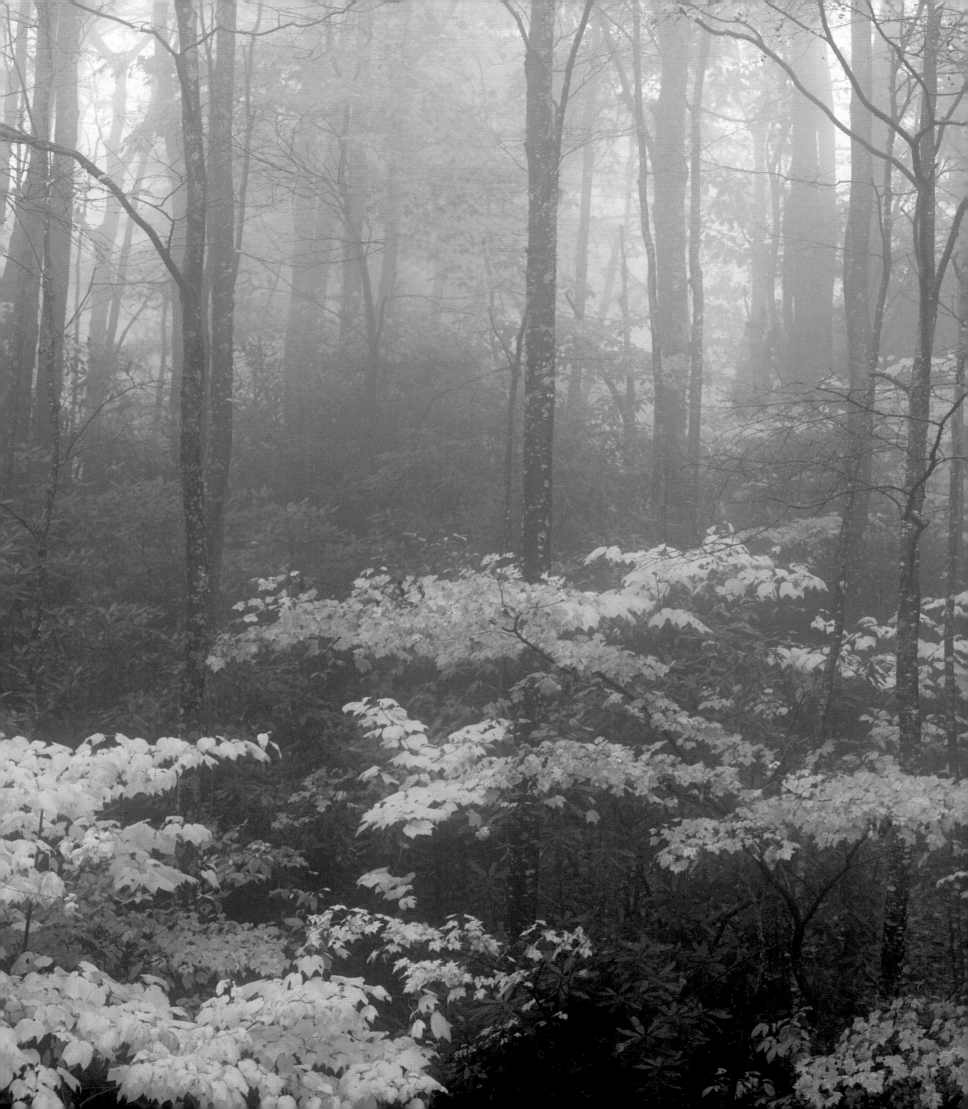

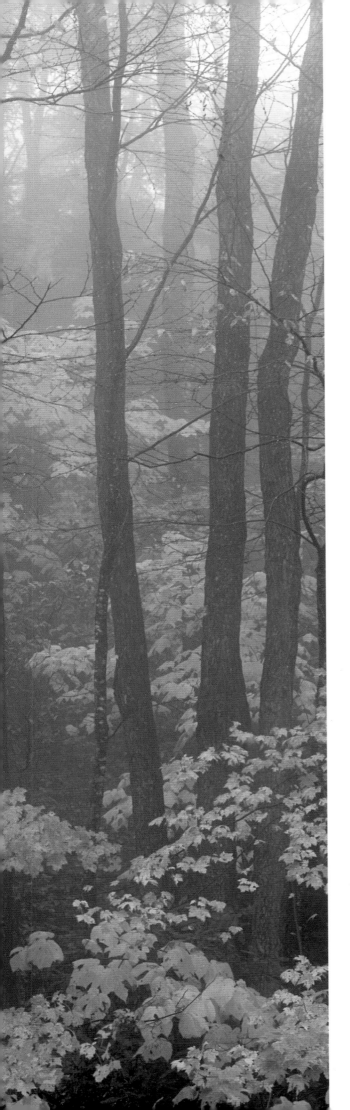

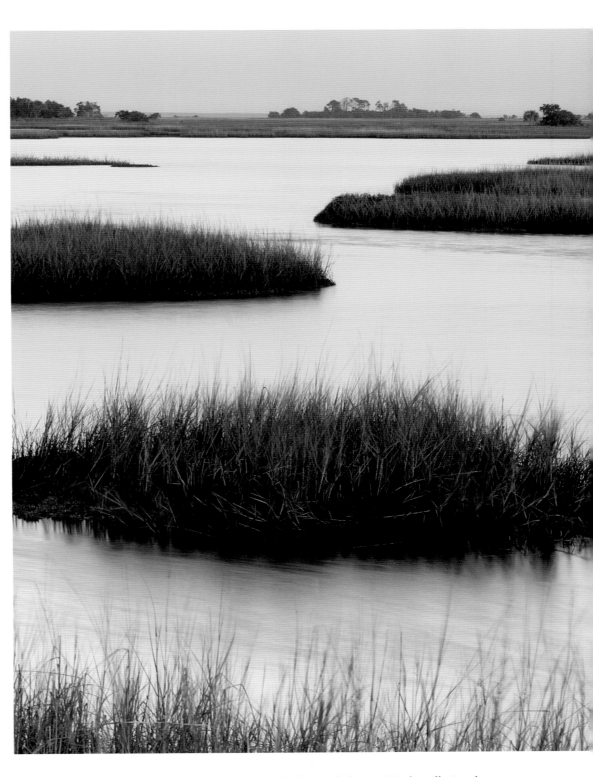

Above: Burnt orange skies are a sign that an August day has ended near Wrightsville Beach.

Left: Fog and mist soften the colors of an October forest near Brevard. The town is home to a population of unique, non-albino white squirrels, which, legend has it, originated from an overturned carnival truck.

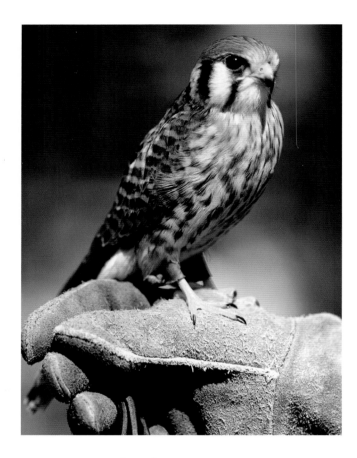

Above: An American kestrel enjoys an outing atop its training companion at the Carolina Raptor Center near Charlotte.

Right: A young hiker surveys a wintery view from atop a rocky lookout on the Appalachian Trail. The famous trail runs through more than 2,100 miles of Appalachian wilderness and through fourteen states.

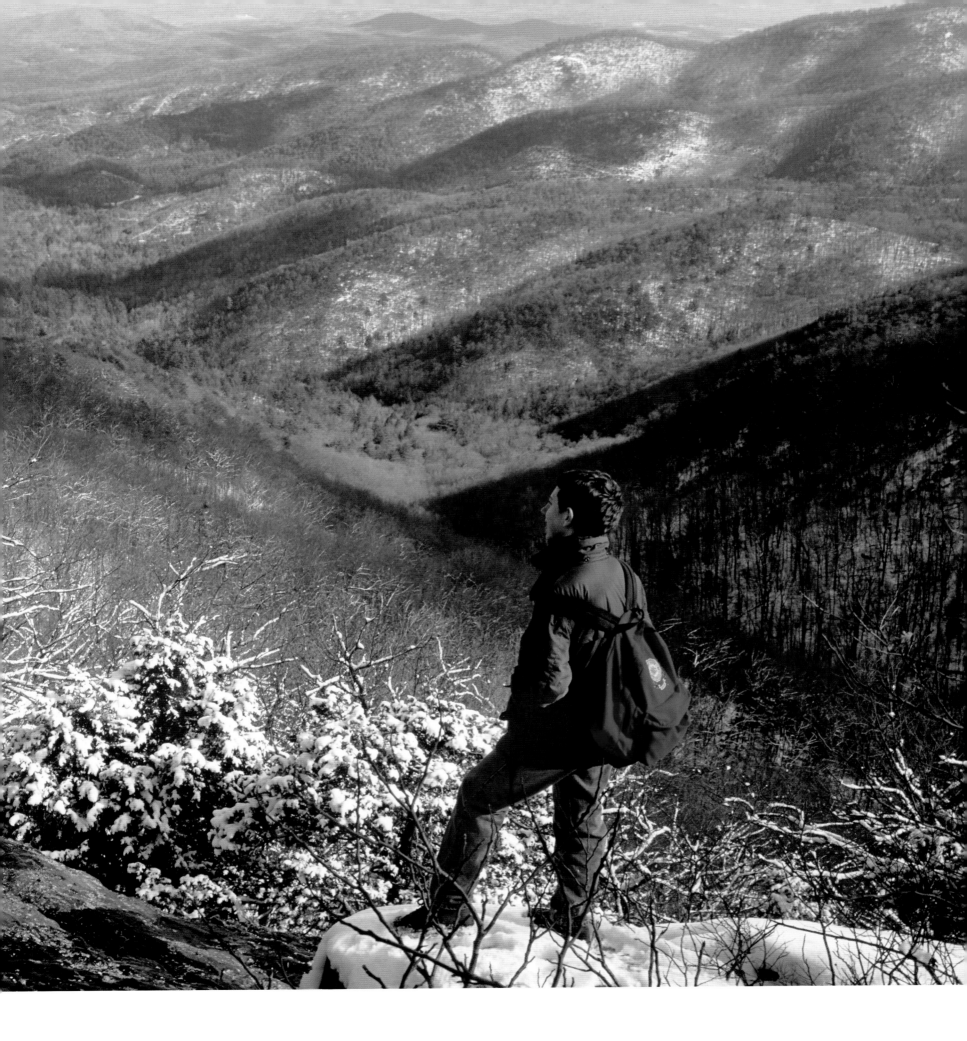

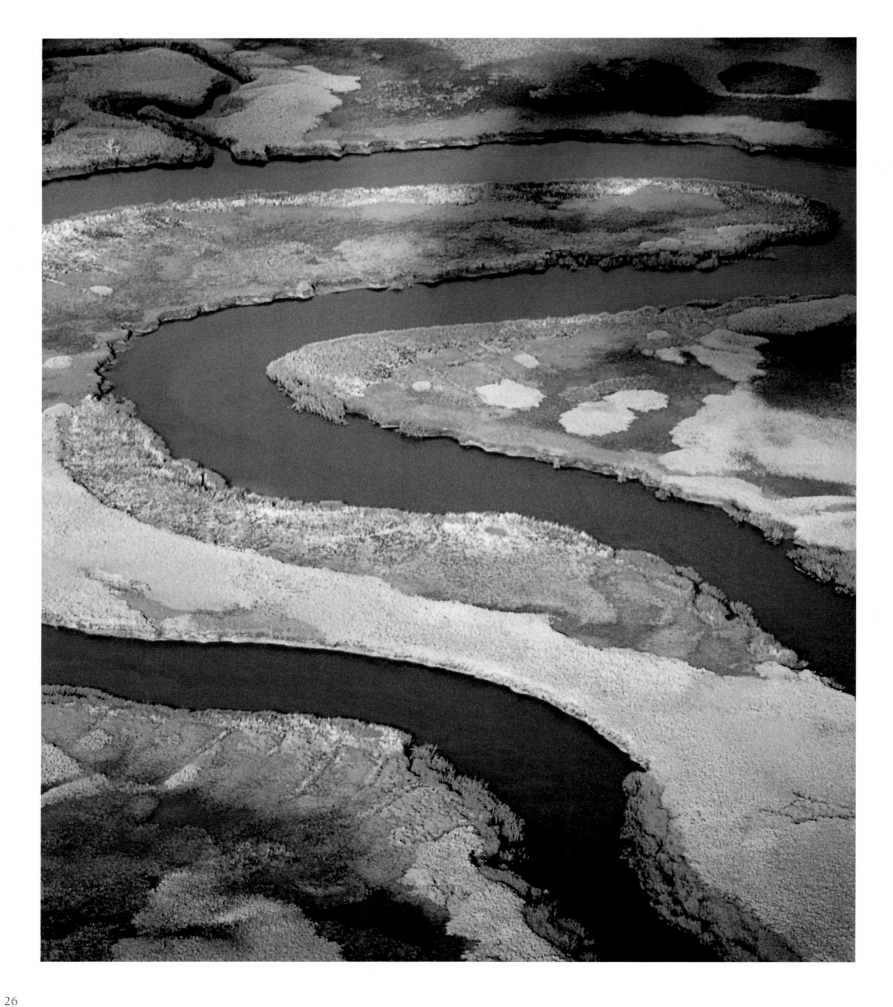

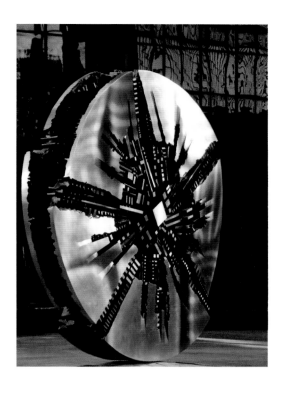

Facing page: The serpentine flow of a tidal creek winds through a fertile marsh along the Carolina coast.

Left: Downtown Charlotte is home to a variety of thought-provoking works of public art like *Il Grande Disco*, a bronze piece by Arnaldo Pomodoro.

Below: Autumn reflections create an impressionistic effect on the surface of Bass Lake in Blowing Rock.

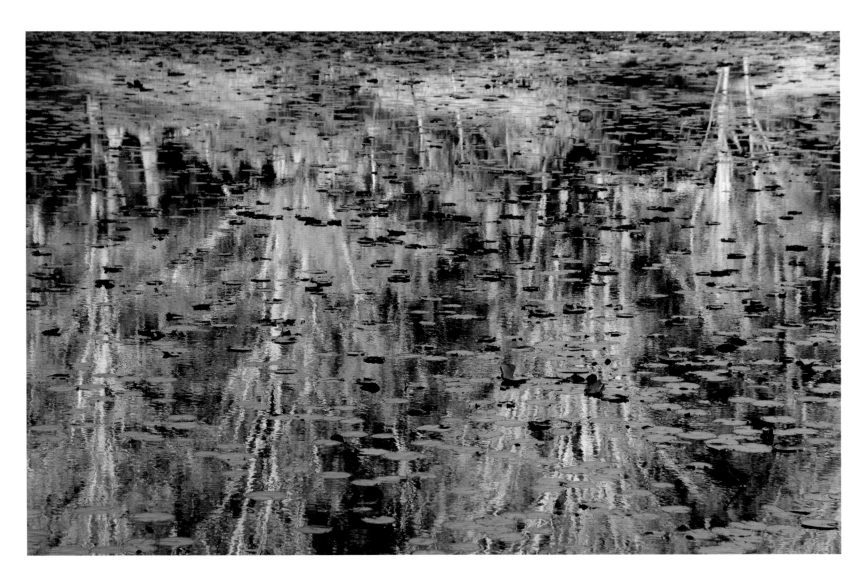

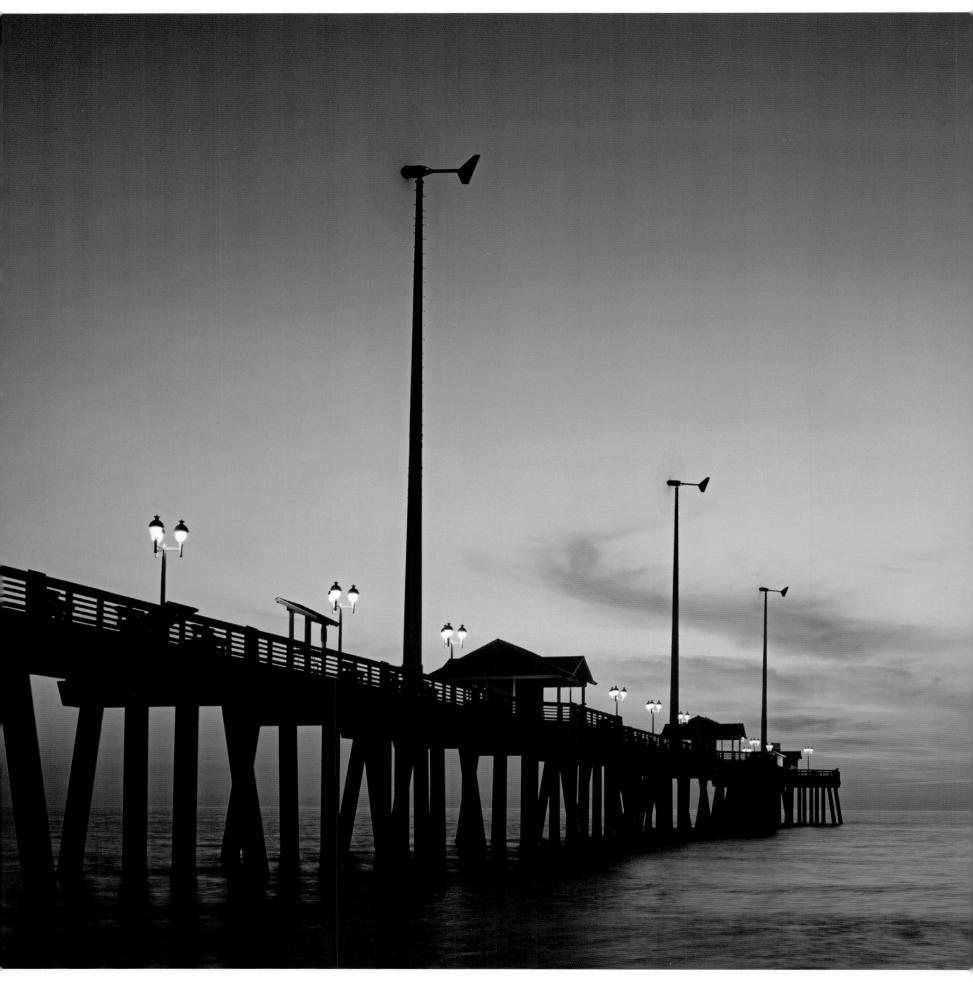

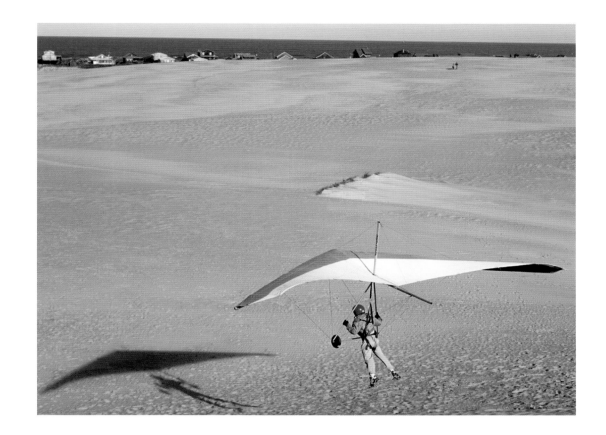

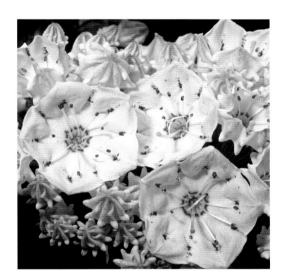

Above: Inspired by the Wright Brothers' flights a few miles north of here, hang gliders can catch a seaside wind and rise above the dunes at Jockey's Ridge State Park.

Left: The charming but poisonous mountain laurel is a flowering shrub that is common in gardens and in the mountains of North Carolina.

Far left: A vivid summer sunrise paints the sky over the Atlantic at Jennette's Pier. First completed in 1939, the pier suffered heavy damage during Hurricane Isabel in 2003. The rebuilt pier offers fishing and education to Nags Head beachgoers.

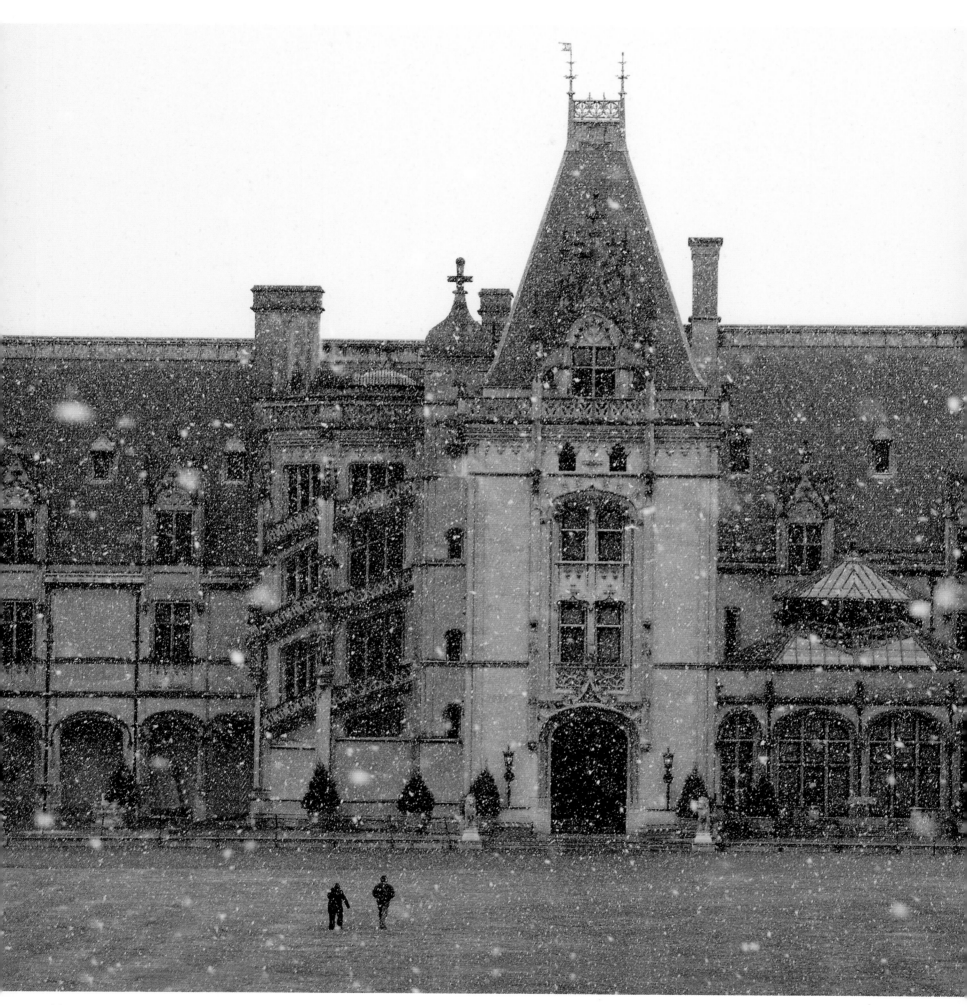

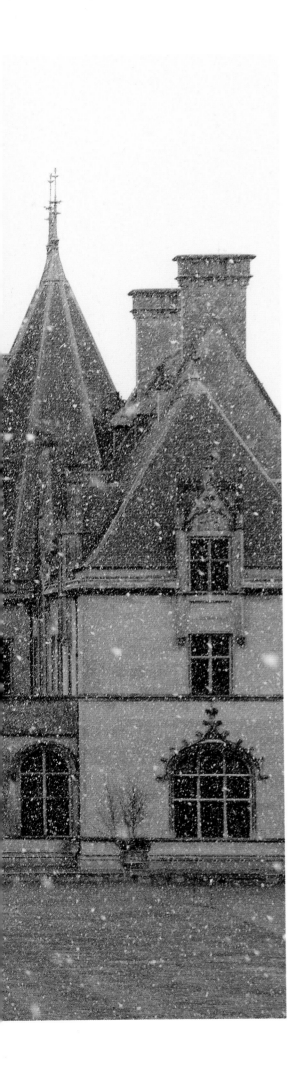

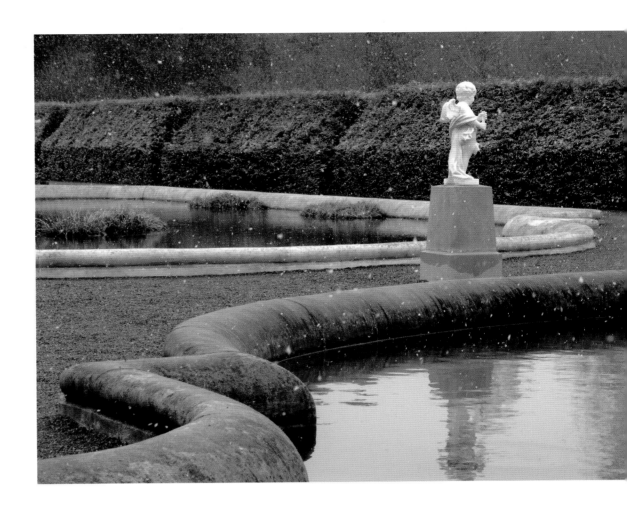

Biltmore Estate is a year-round destination filled with grandeur and history—a wonderful place to explore, even on a snowy winter day. The exquisite, 250-room mansion was the home of George and Edith Vanderbilt and was completed in 1895. The largest private home in America, the house features intricately carved architectural details, acres of gardens, and priceless art.

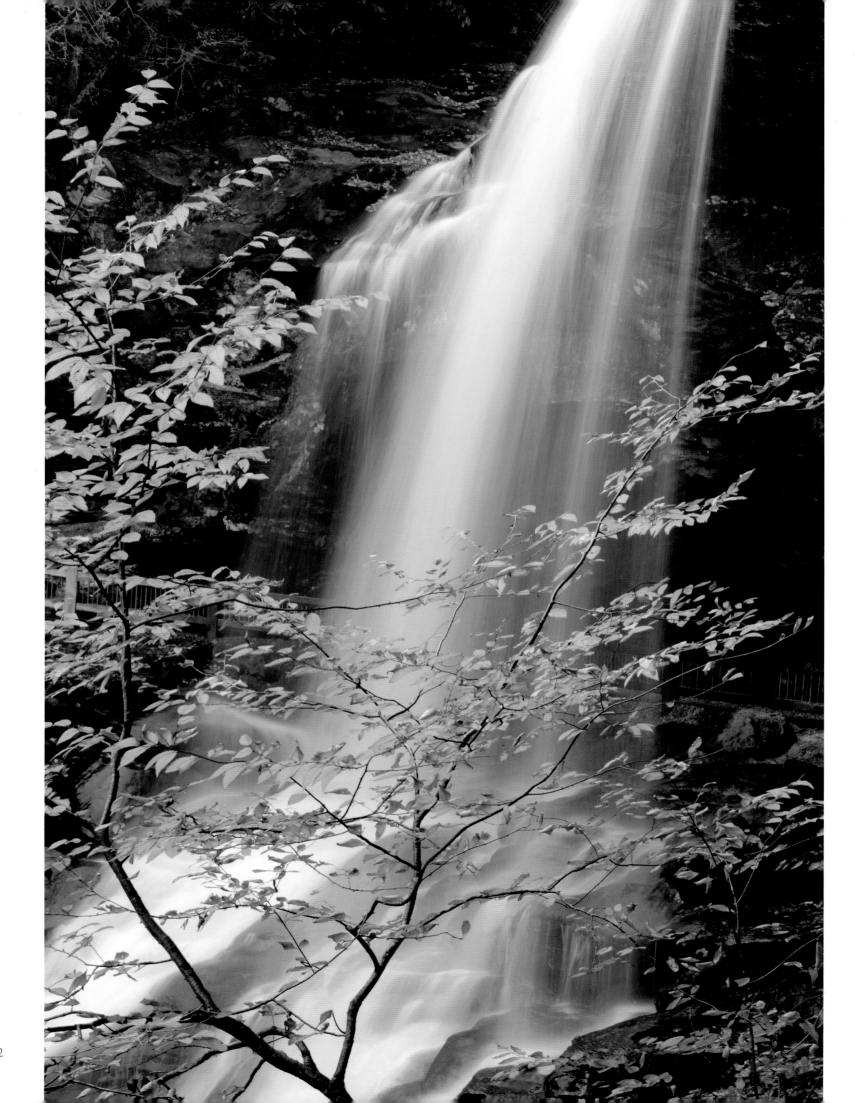

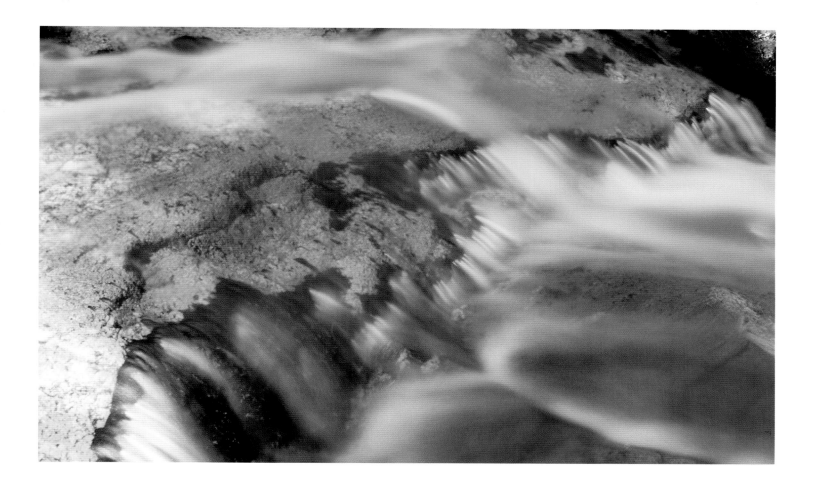

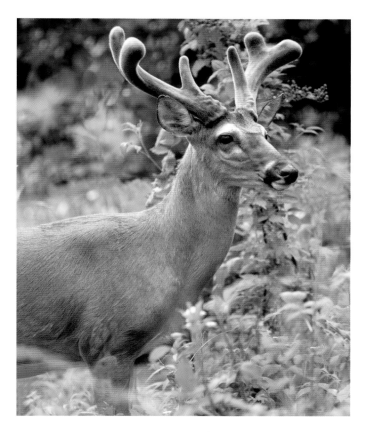

Above: A rushing cascade tumbles over a colorful streambed in the mountains near Franklin. Cold, clear streams found in the Smokies offer excellent habitat for native fish, making them prized by anglers.

Left: A whitetail buck sports velvet-covered antlers as he roams the woodlands of the Great Smoky Mountains.

Facing page : Dry Falls, seen here at the peak of the autumn season, is a popular stop in Nantahala National Forest. One can explore the falls by actually walking behind the cataract without getting wet—which is how this graceful waterfall earned its name.

Facing page: A reenactor in period clothing saunters down the street in the historic district of Old Salem. Settlers seeking freedom of worship established the town in 1766. Today, Old Salem is a living history museum dedicated to preserving and educating visitors about daily life as it was in the eighteenth and nineteenth centuries.

Right: Cotton is still cultivated on North Carolina's fertile fields, just as it has been for generations.

Below: Clouds hover over the distinctive silhouetted shape of Grandfather Mountain, its outline said to resemble the profile of an old man. The 5,946-foot mountain is one of the tallest in the Blue Ridge Mountains and offers views from its famous Mile High Swinging Bridge.

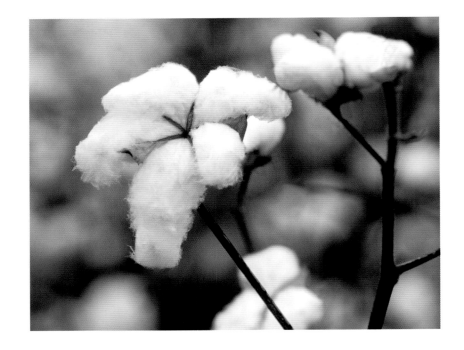

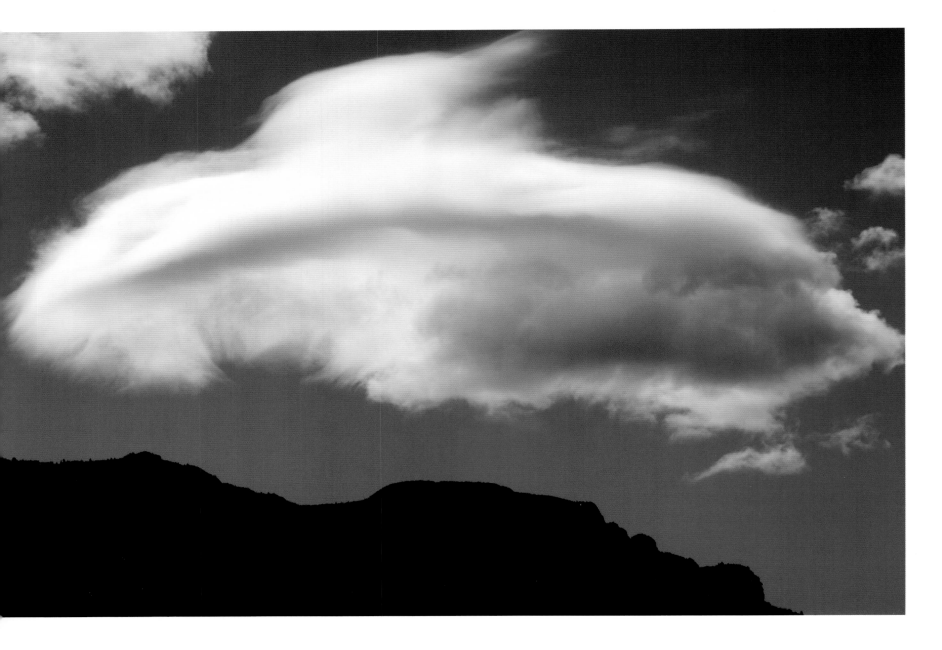

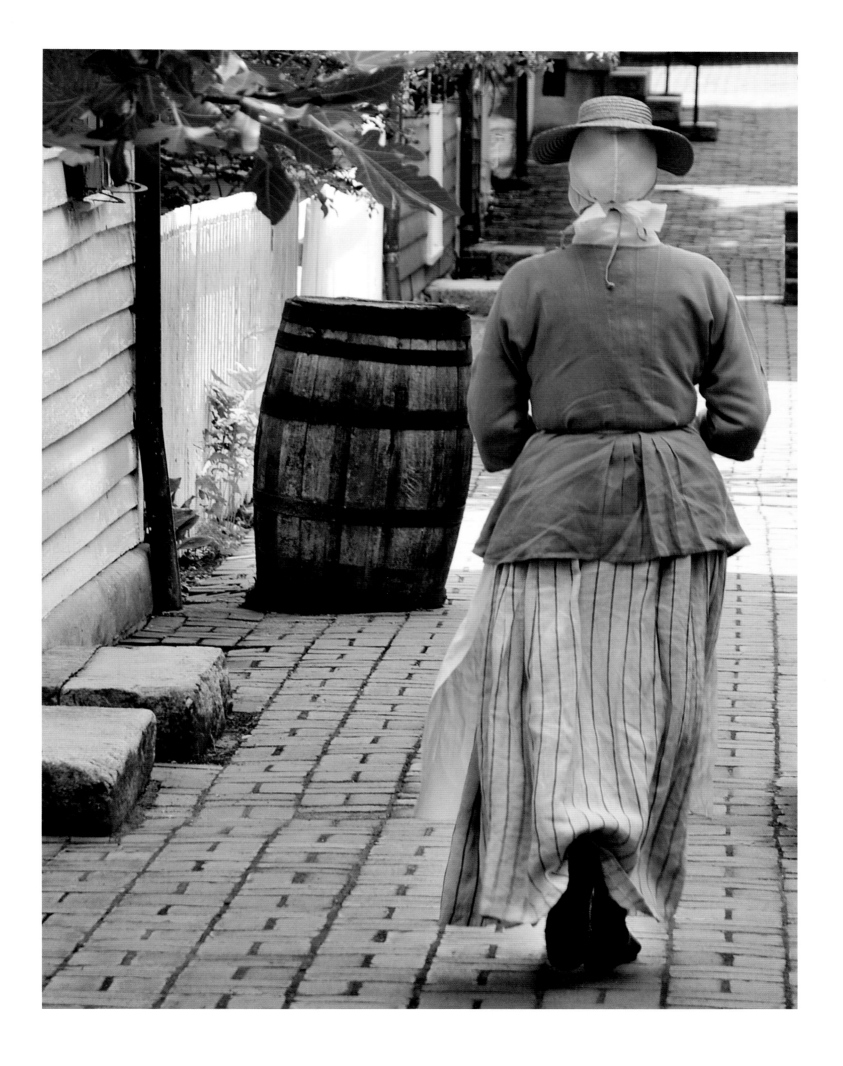

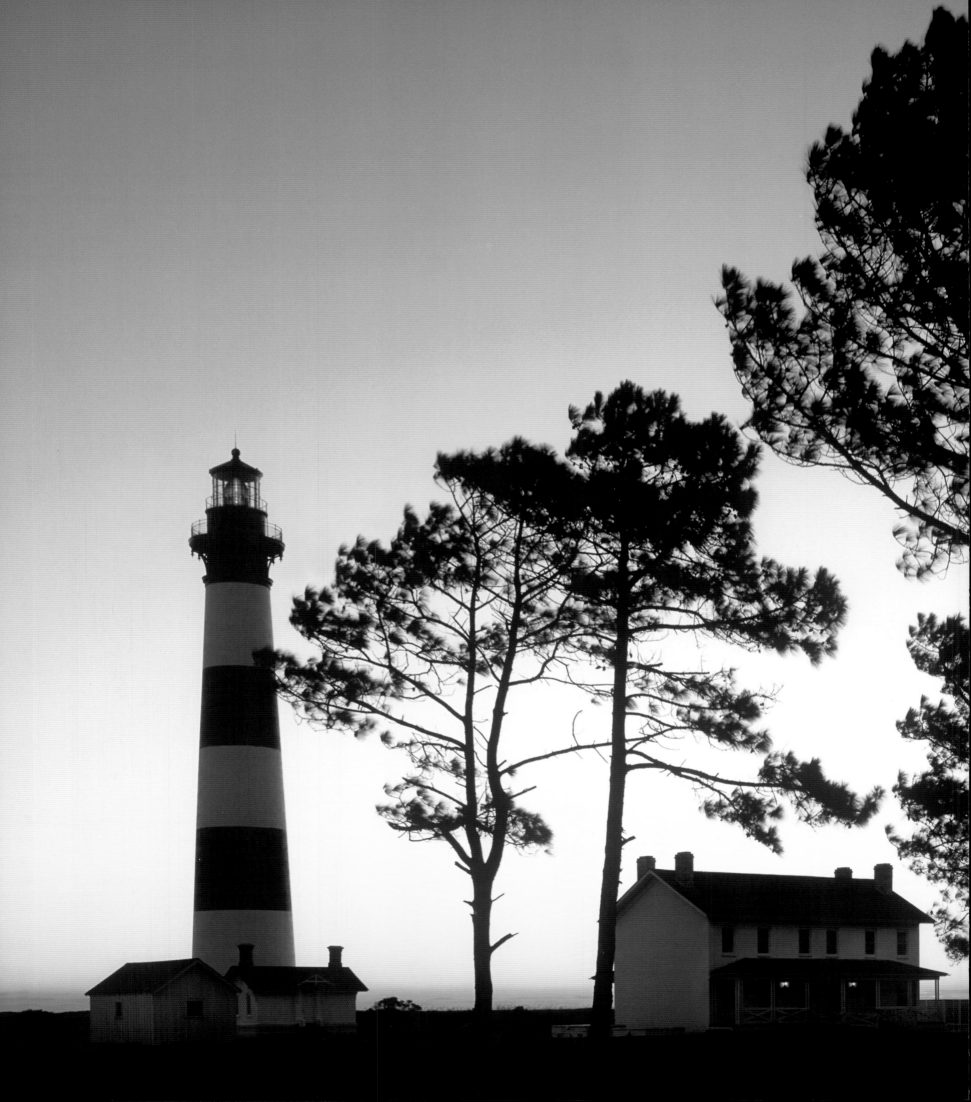

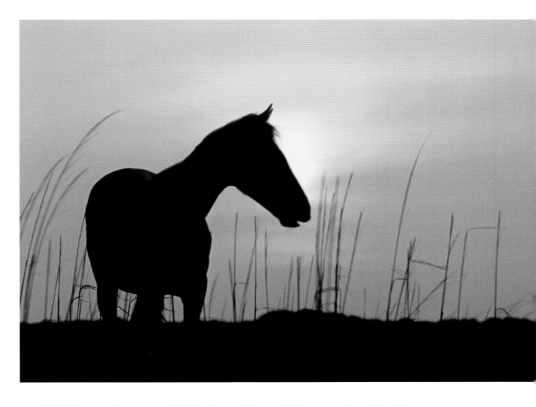

Above: Wild horses known as "Banker horses" can still be seen along the Outer Banks. They are descendants of Spanish horses that came ashore with the first European explorers.

Left: Not quite finished for the night, Bodie Island Lighthouse burns bright in the early morning dawn. The 1872 lighthouse still aids mariners in navigating the dangerous waters around the island.

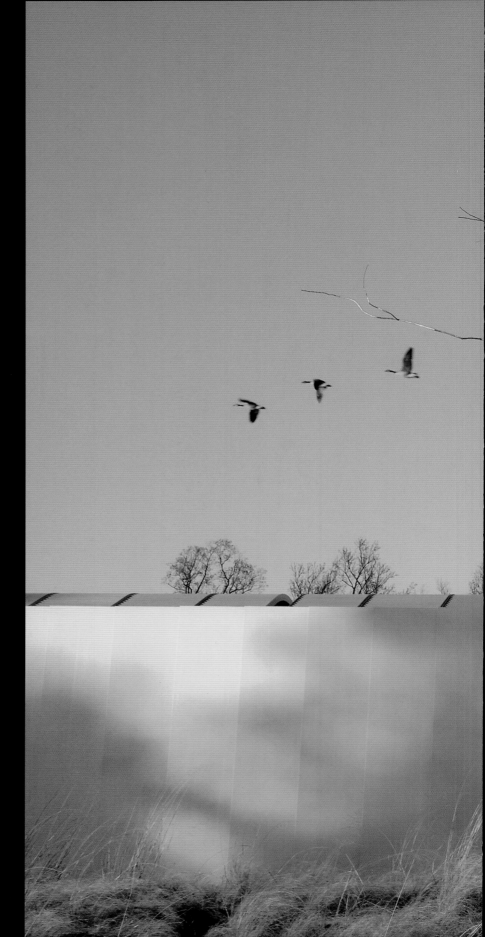

Right: Outside the North Carolina Museum of Art, the forty-three-foot stainless steel sculpture *Askew,* by Roxy Paine, mimics the form of nature while a trio of geese flies by in appreciation.

Below: A glassblowing artist creates a unique piece at his workshop in Asheville.

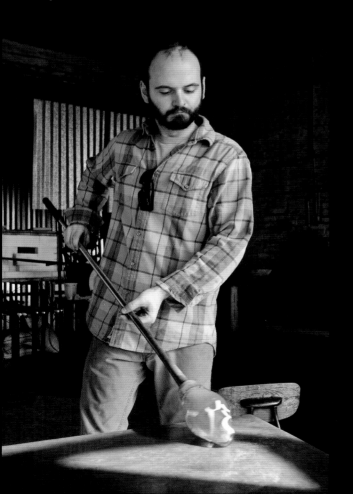

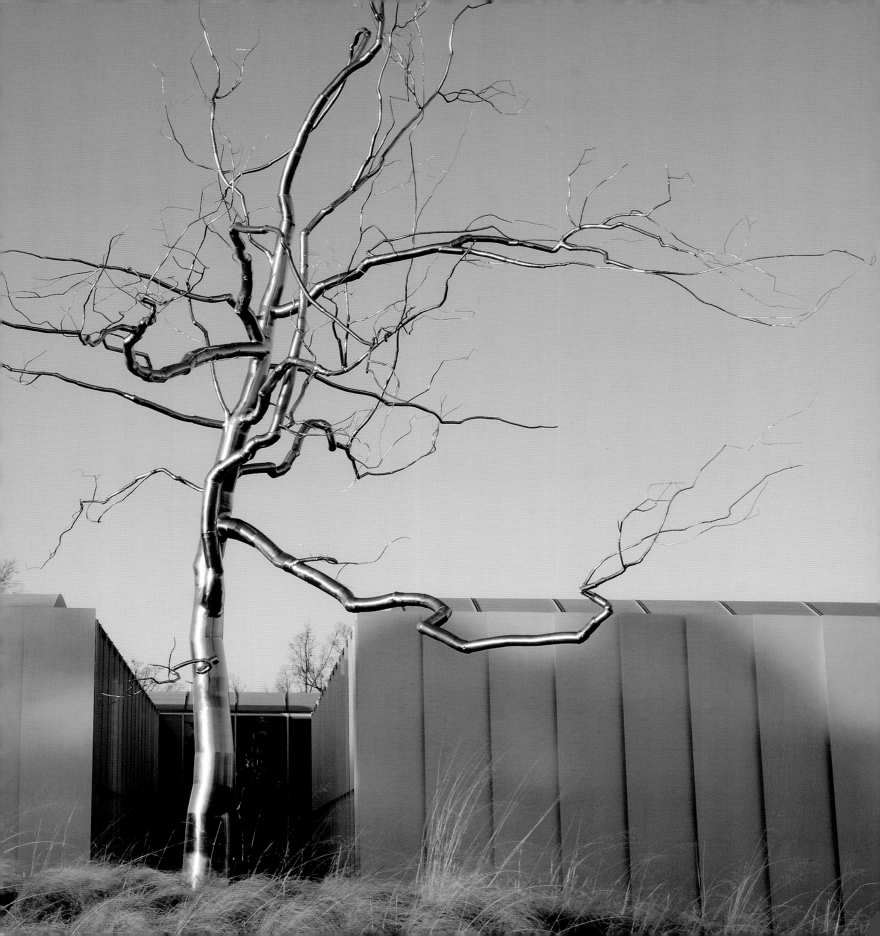

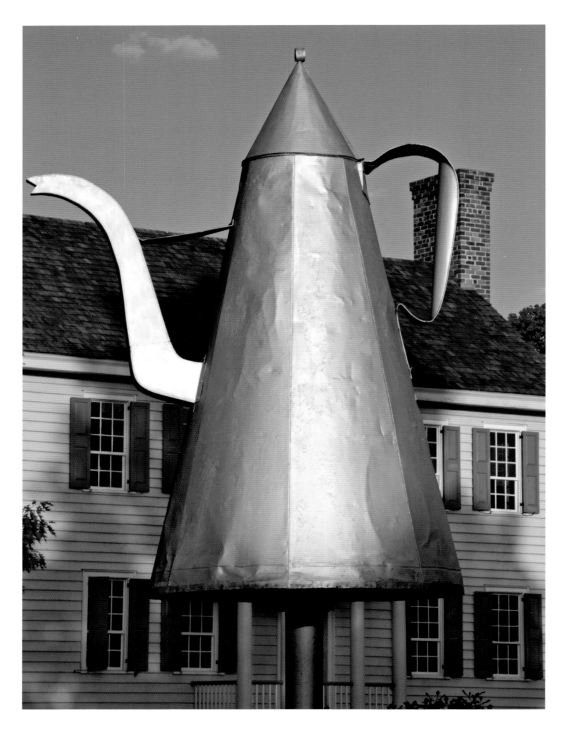

Above: This 740-gallon tin coffee pot at the entrance to Old Salem was originally constructed by tinsmiths Julius and Samuel Mickey in 1858 to advertise their shop. It is now a beloved local landmark.

Facing page: The Mountain Farm Museum is a collection of rustic log buildings at the Oconoluftee entrance to Great Smoky Mountains National Park. The buildings, brought together from locations throughout the park, provide a glimpse into the park's past.

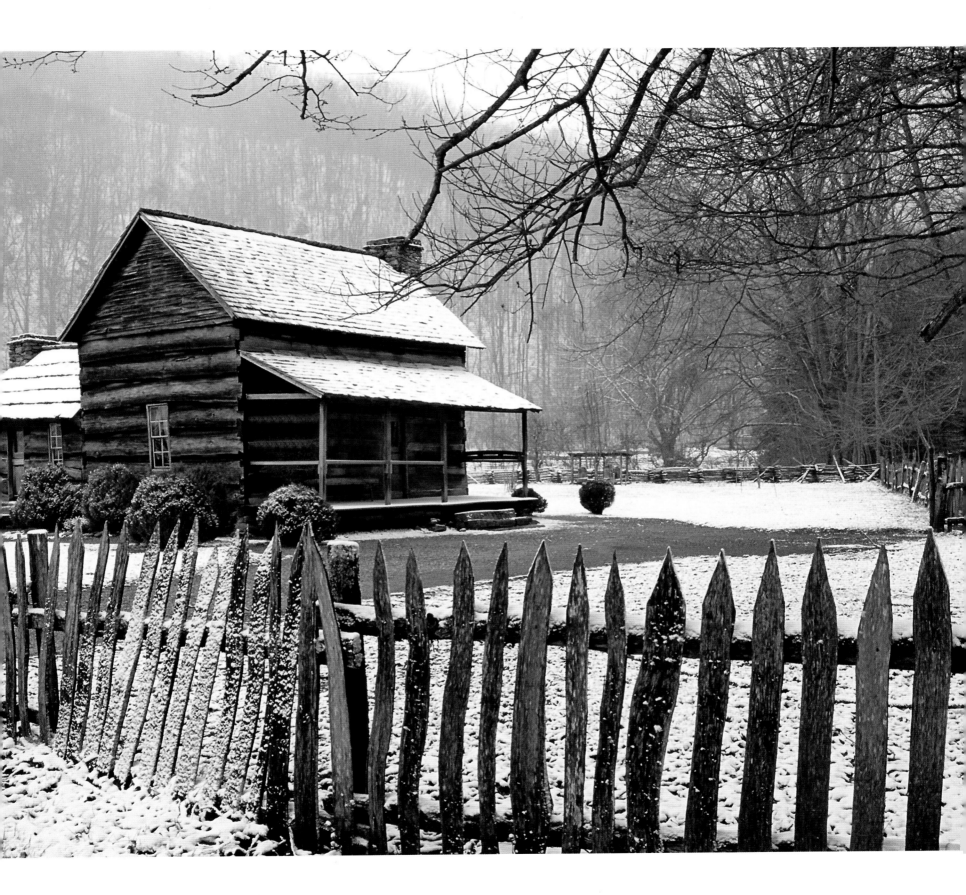

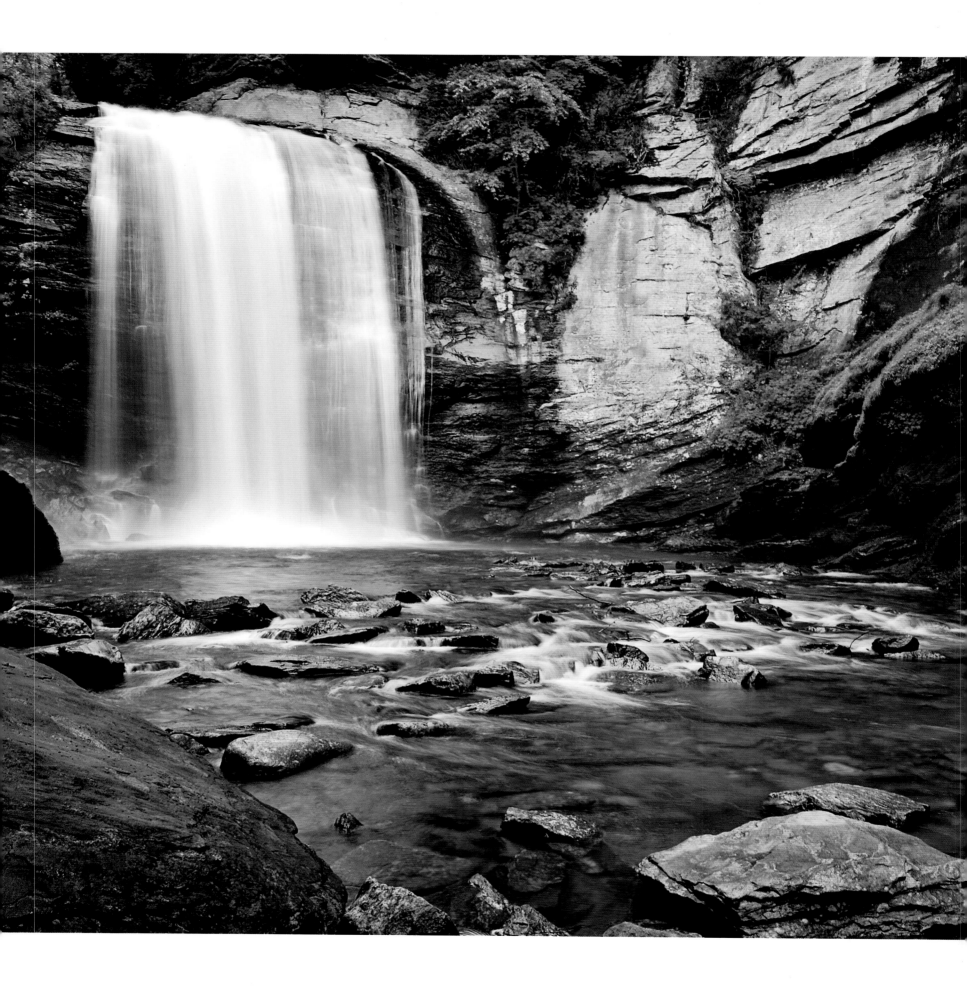

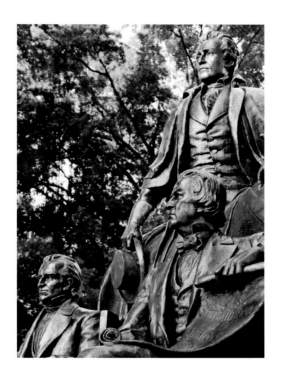

Far left: Located in Pisgah National Forest, Looking Glass Falls takes its name from the nearby rock face, which sometimes freezes with water on its surface. The rock then glistens in the sunlight like a mirror or looking glass.

Left: Standing proud outside the state capitol, *Presidents North Carolina Gave the Nation* honors all three North Carolina-born presidents: Andrew Jackson, James Polk, and Andrew Johnson.

Below: Along Highway 12, the beachside road through Cape Hatteras National Seashore, coastal winds and shifting sands constantly remake a dynamic landscape.

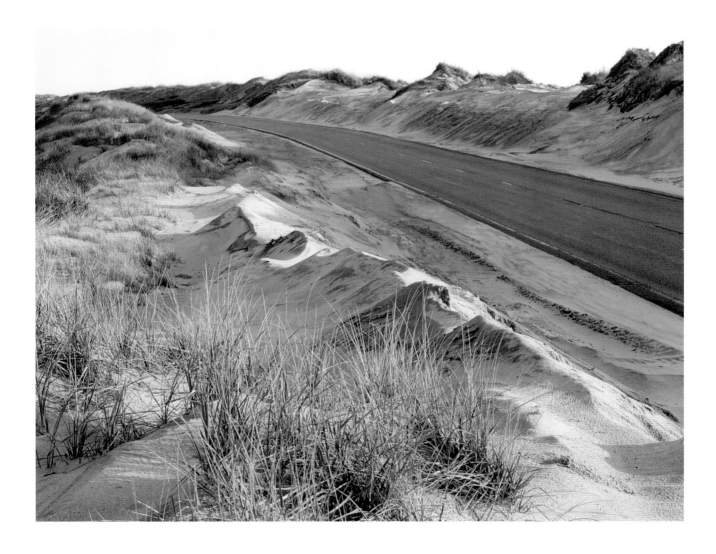

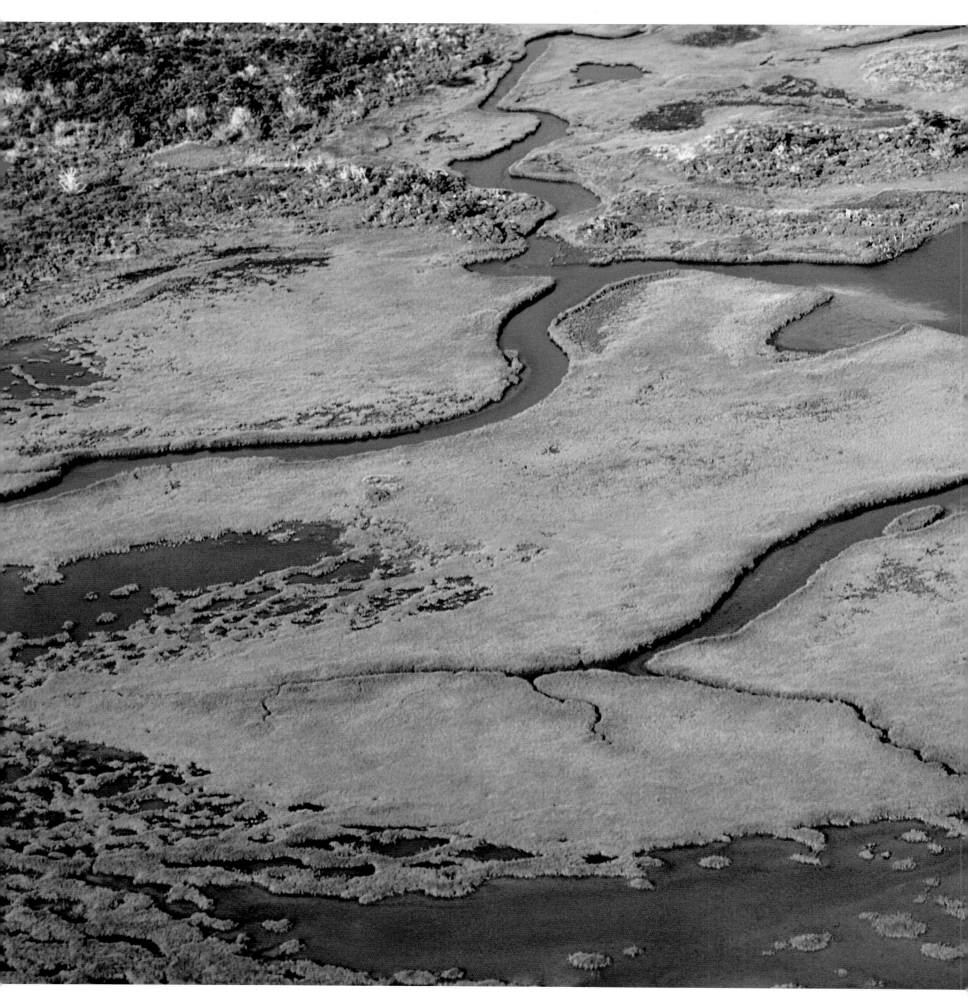

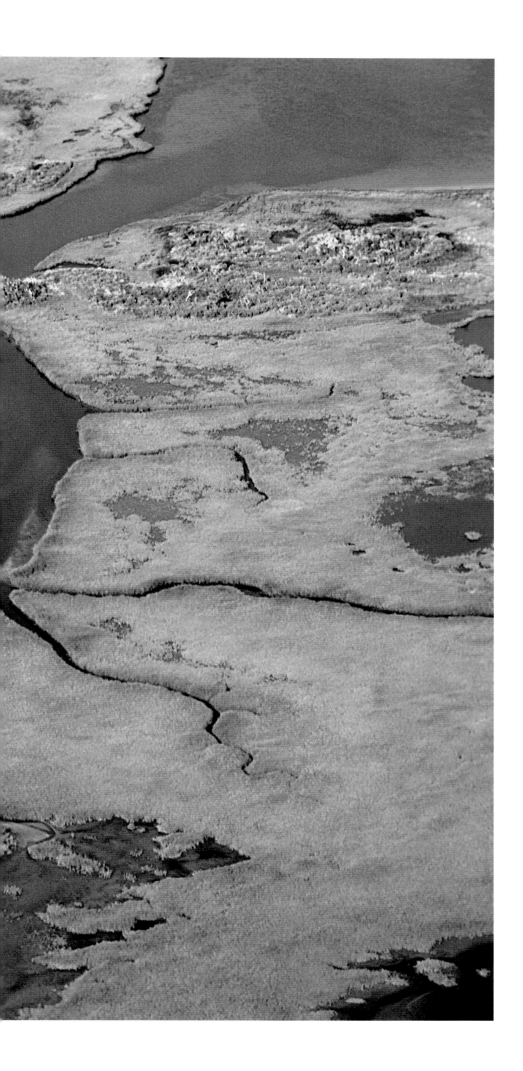

Left: The lush carpet of the saltwater marsh spreads across parts of the thirteen-mile-long Pea Island National Wildlife Refuge.

Below: Spiritual illumination awaits visitors to Wait Chapel on the campus of Wake Forest University, where light streams through tall windows.

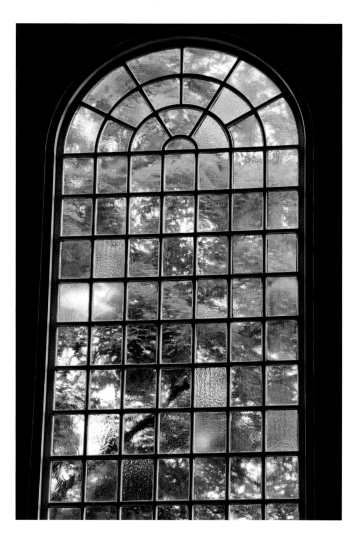

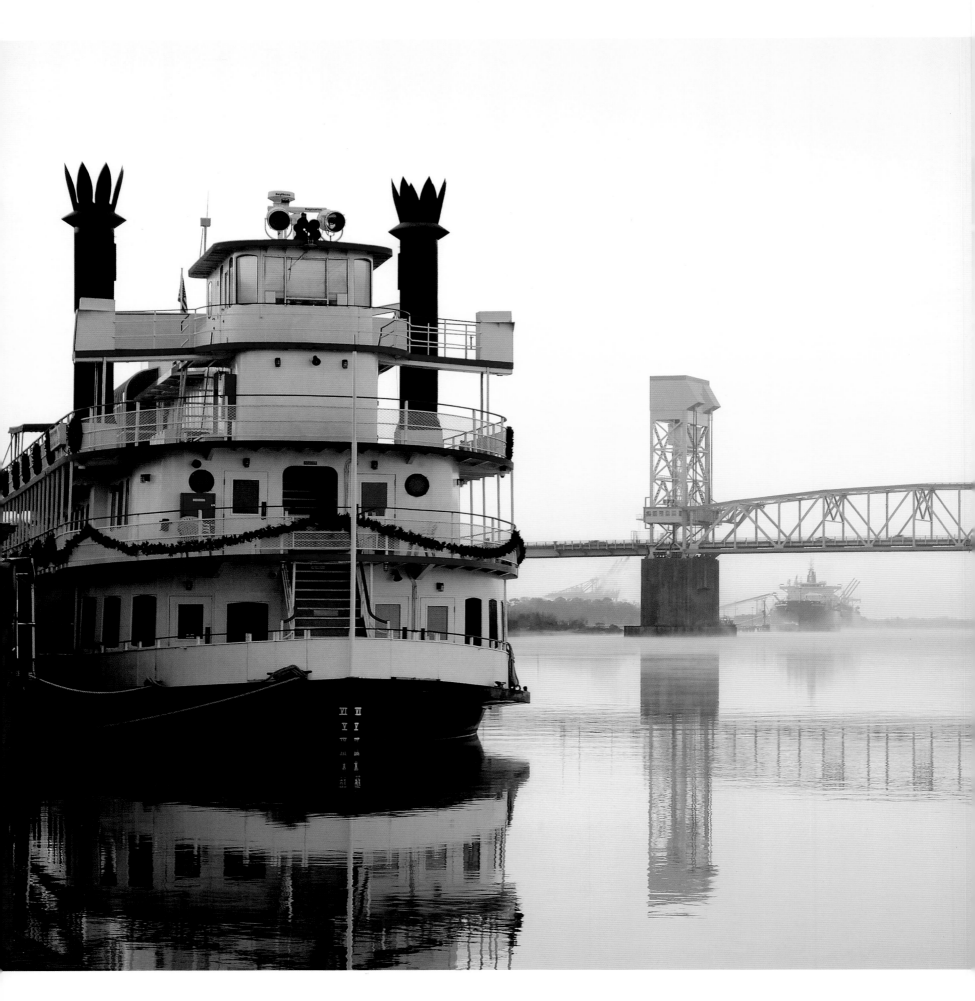

Left: A riverboat docked along the banks of the mighty Cape Fear River evokes earlier times. The port of Wilmington, obscured by the morning mist, lies beyond Cape Fear Memorial Bridge.

Below: Battleship USS *North Carolina* now floats peacefully as a memorial and museum on the Wilmington waterfront, but it was once a fighting vessel that served with distinction in the Pacific Theater during World War II.

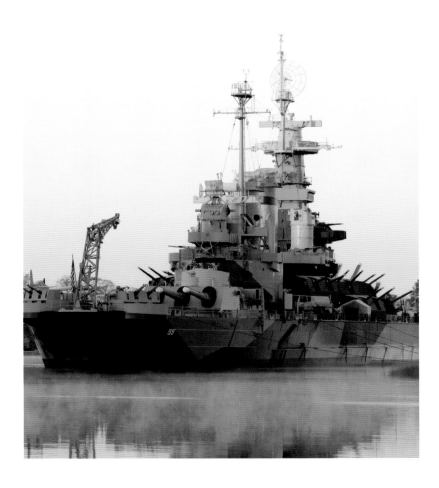

Facing page: Linn Cove Viaduct is an engineering marvel that snakes around the slopes of Grandfather Mountain. It is an iconic symbol of the Blue Ridge Parkway, where new wonders and rugged beauty await around every turn.

Right: America's first documented gold discovery came at the site of Reed's Gold Mine in 1799 when twelve-year-old Conrad Reed spotted a sparkling yellow rock shining in the waters of Little Meadow Creek. The seventeen-pound "rock" was reportedly used as a doorstop for several years before it was revealed to be gold.

Below: The Battle of Guilford Courthouse was fought on March 15, 1781, seven months before the end of the Revolution. It was a hotly contested fight, and the British commander later said that the Americans "fought like demons."

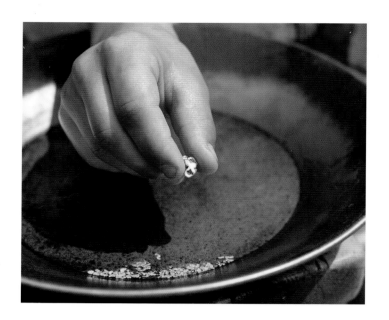

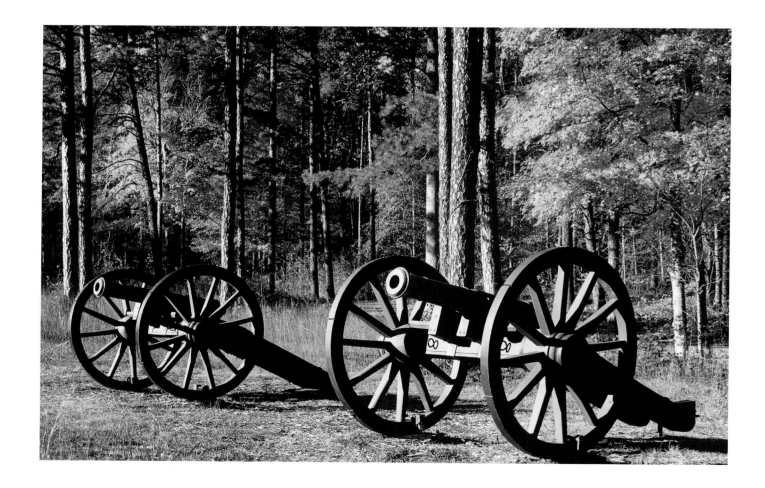

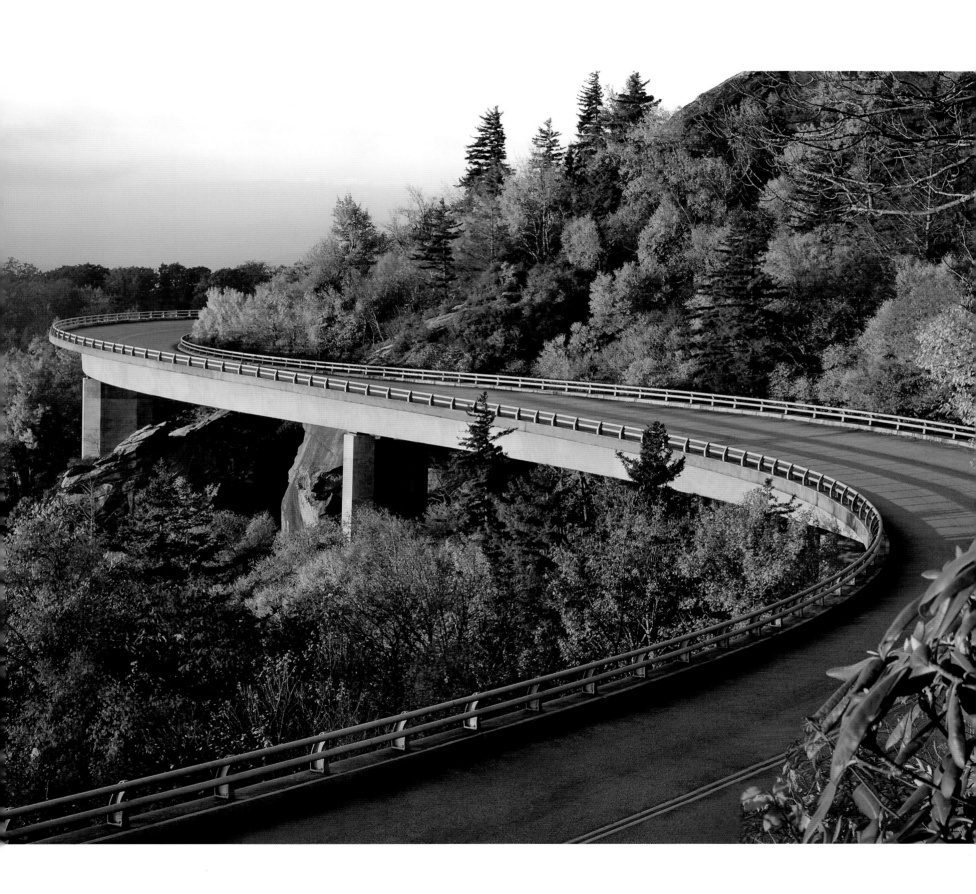

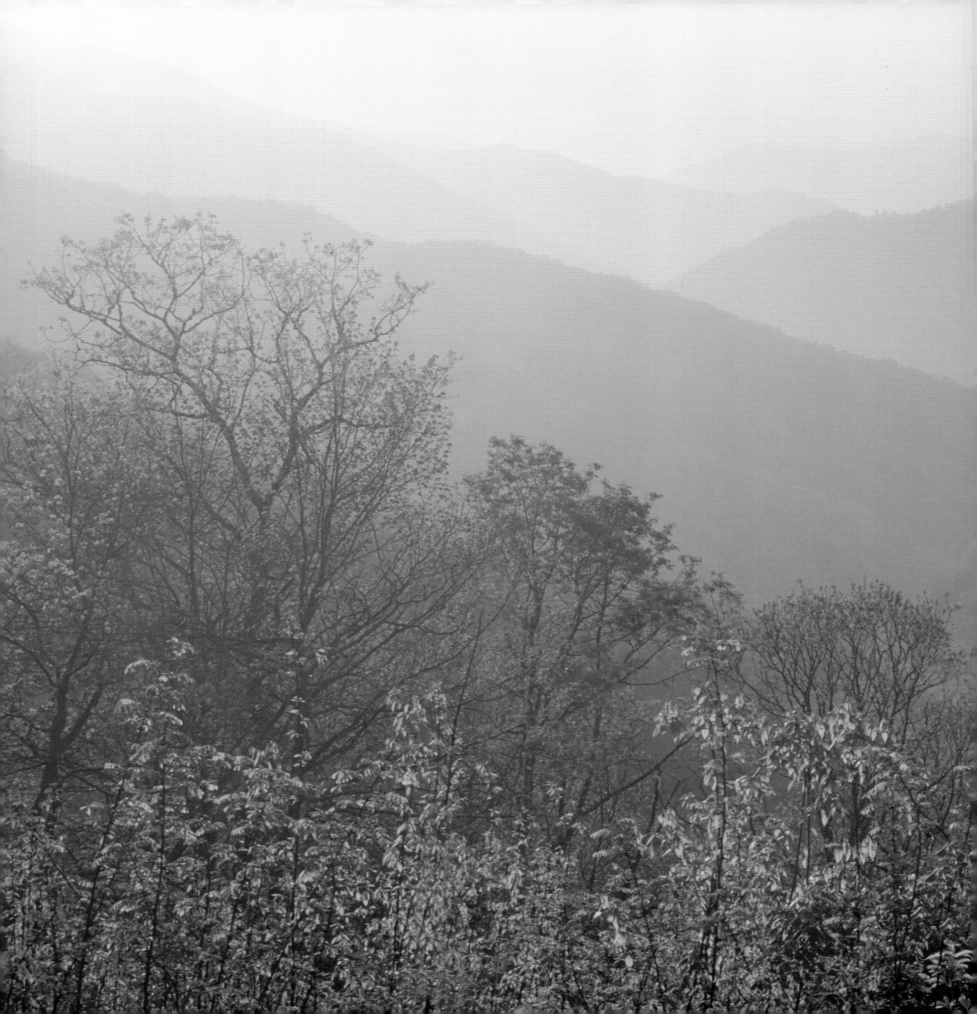

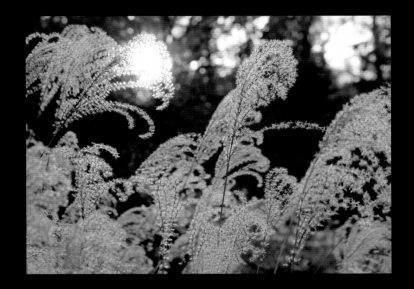

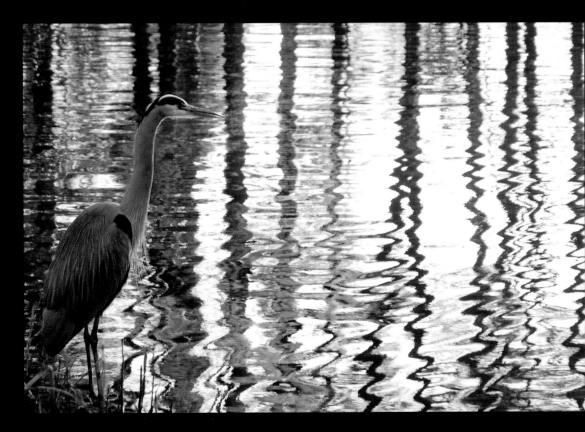

Above, top: Early winter sunlight highlights delicate details in a Raleigh garden.

Above, bottom: A lakeside breeze bends watery shadows behind a long-legged great blue heron. This species can grow to a height of over 4.5 feet, with a wingspan of 6.5 feet.

Left: The soft green and yellow hues of spring foliage frame distant mountain ridges near Waterrock Knob on the Blue Ridge Parkway.

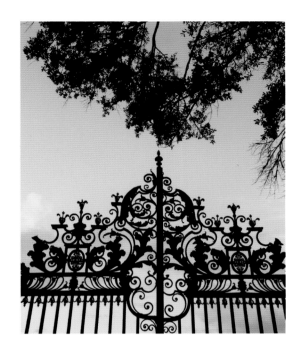

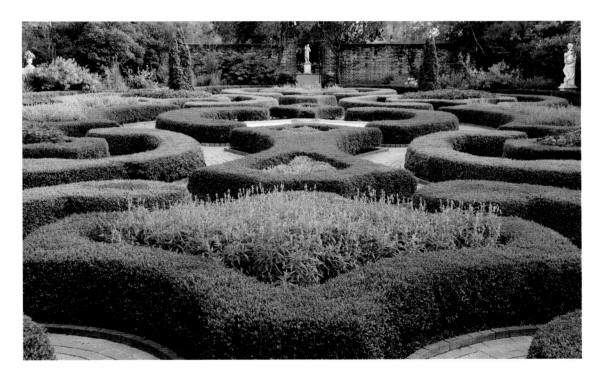

Above, top: At Tryon Palace in New Bern, an ornate gate guards the entrance to historic grounds on the banks of the Neuse River.

Above, bottom: Maude Moore Latham Memorial Garden is a beautiful place for reflection at Tyron Palace. The formal garden honors Latham's efforts to restore the Palace.

Left: Tryon Palace was reconstructed in 1959 to commemorate the original Royal Governor's Palace, which was built in 1770 and ultimately lost to fire. It was North Carolina's first permanent state capitol.

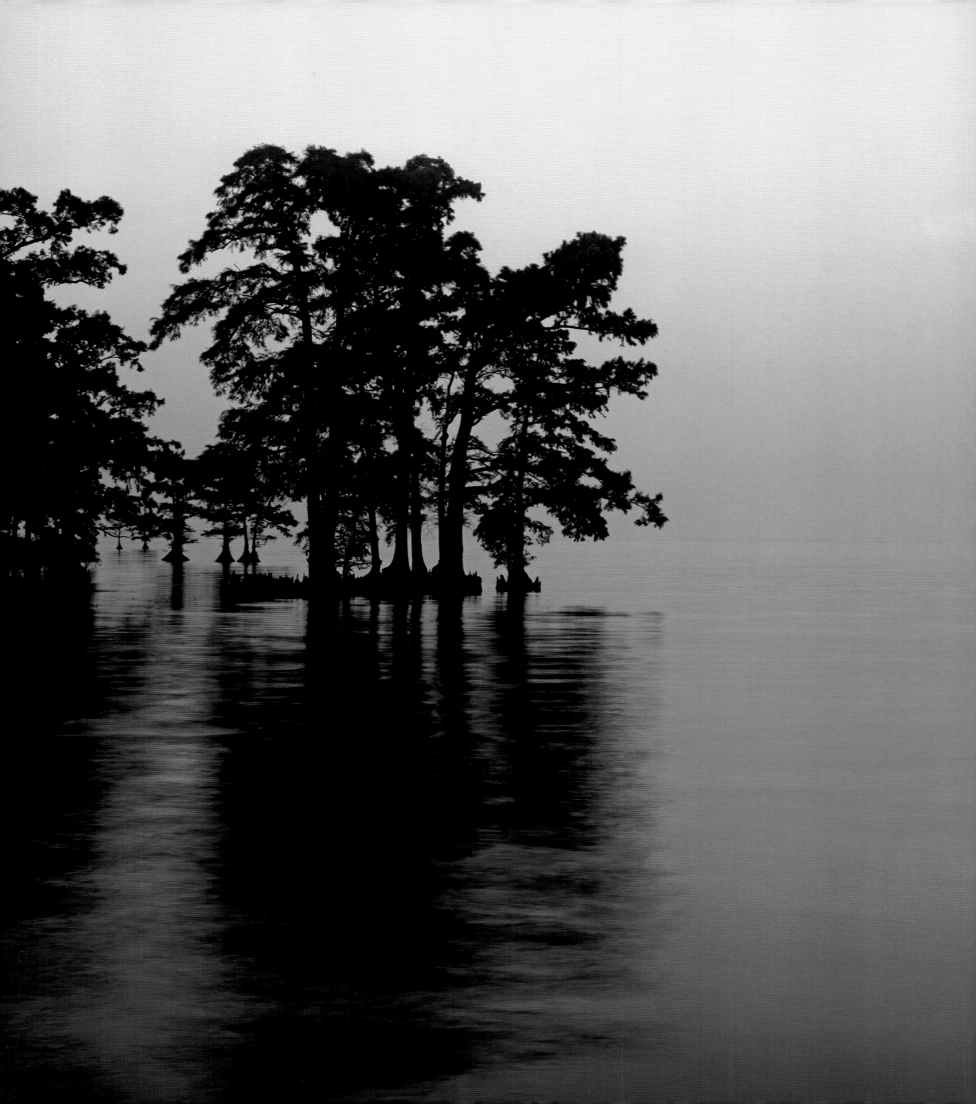

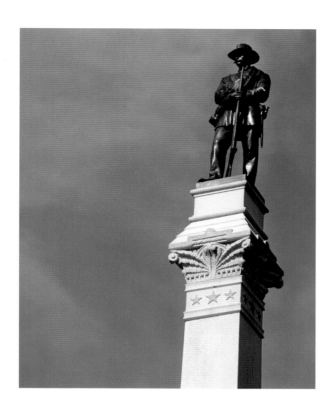

Facing page: In Edenton, cypress trees appear to float on the surface of Albemarle Sound on a humid July morning.

Left: This monument to North Carolina's Confederate casualties stands at the entrance to the capitol grounds in Raleigh.

Below: Shorebirds wade through the shallows of an inlet near Cape Hatteras at low tide.

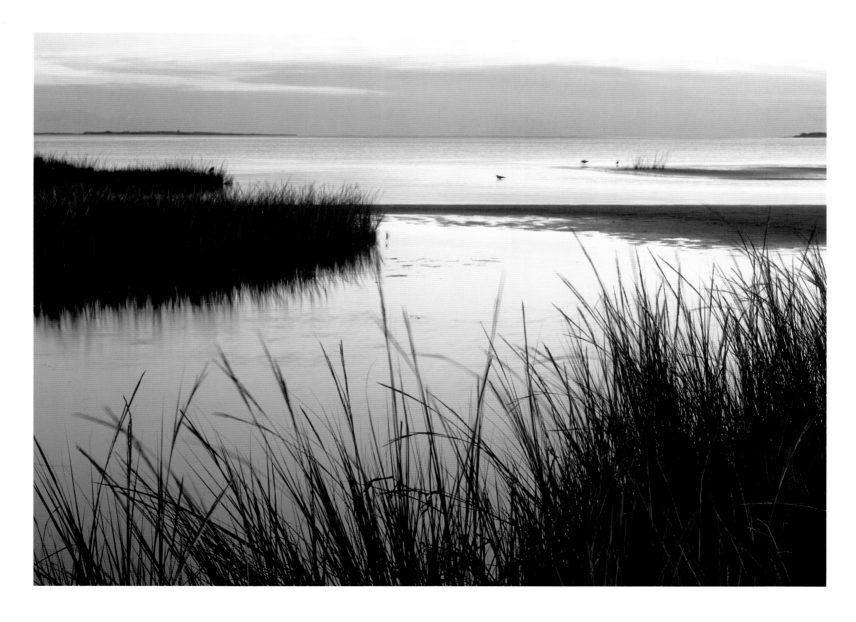

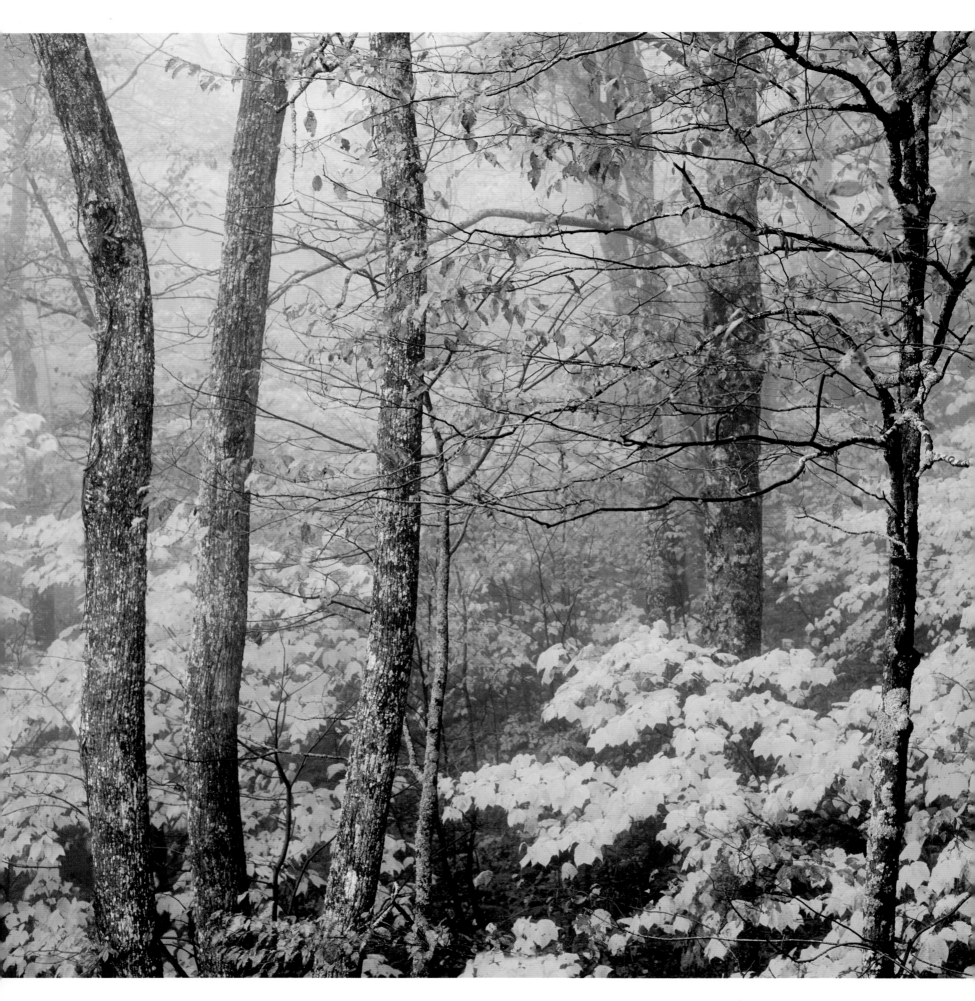

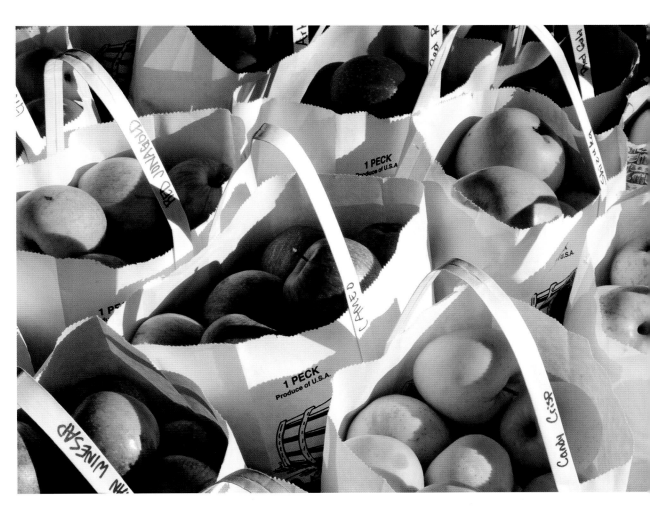

Above: An autumn stroll down Main Street in Blowing Rock reveals apples for sale among rustic galleries and shops.

Left: Near the southern terminus of the Blue Ridge Parkway, mist and fog soften the vibrant yellow foliage of a fall forest.

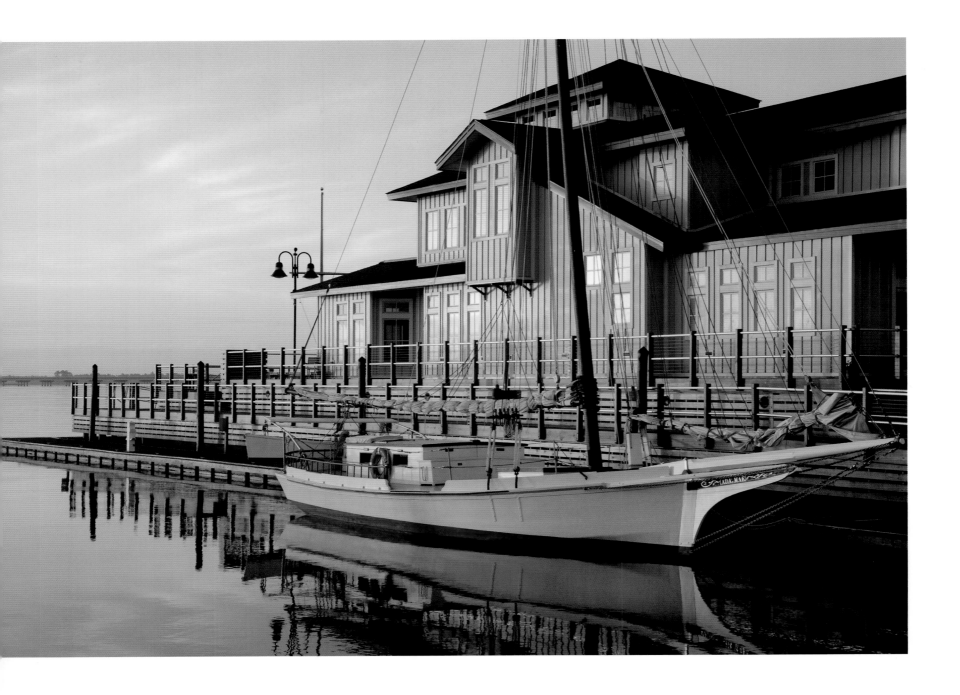

Above: The skipjack *Ada Mae* quietly awaits her next voyage on a bright morning in New Bern.

Right: A sand bar shark patrols the waters of Greensboro Science Center's Carolina SciQuarium. The center entertains and educates families with its zoo, aquarium, dome-shaped theater, and hands-on museum.

Facing page: Cool morning light appears behind the beacon of the Ocracoke Island Lighthouse. Opened in 1823, Ocracoke is the second-oldest lighthouse still in operation in the United States.

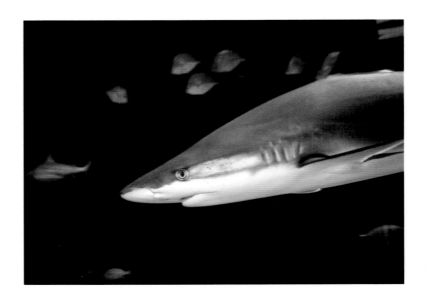

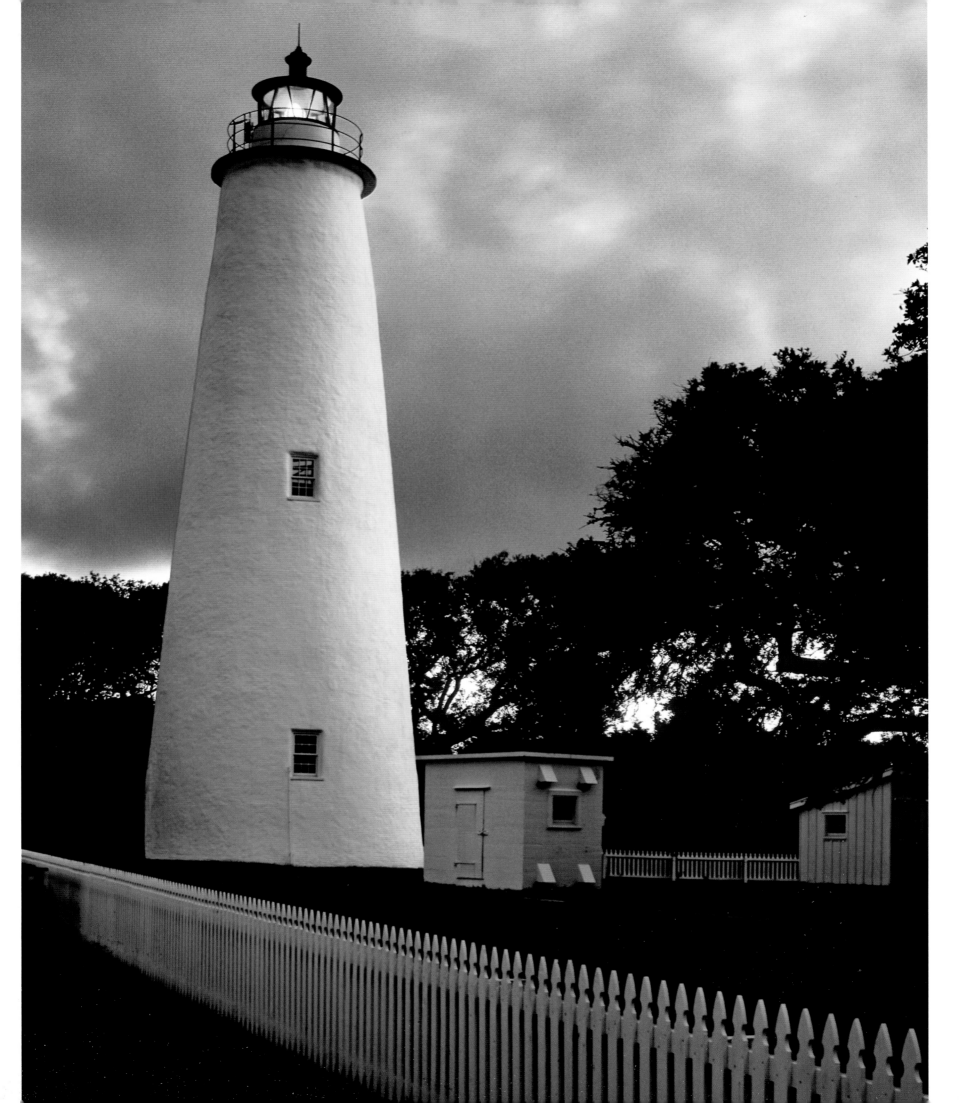

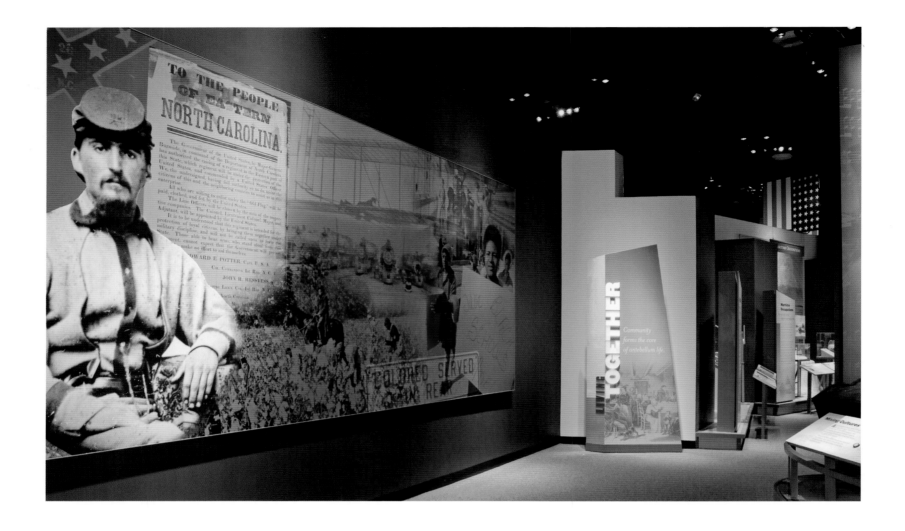

Above: This gallery at the North Carolina Museum of History interprets the state's story in a colorful timeline from its earliest inhabitants through the twentieth century.

Right: The saturated colors of autumn are found in woodlands near the village of Little Switzerland.

Facing page: Five-sided Fort Macon was completed in 1834 to protect the entry to the port of Beaufort. The fort, now a state park, boasts outer walls that are 4.5 feet thick.

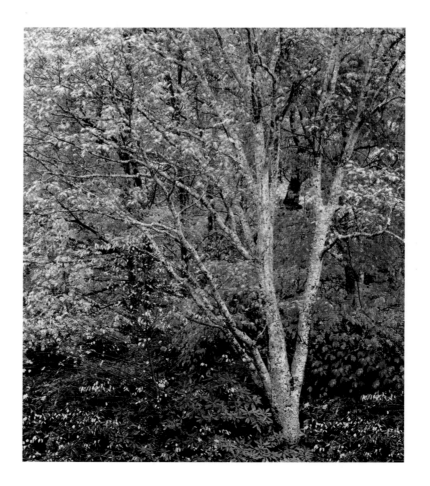

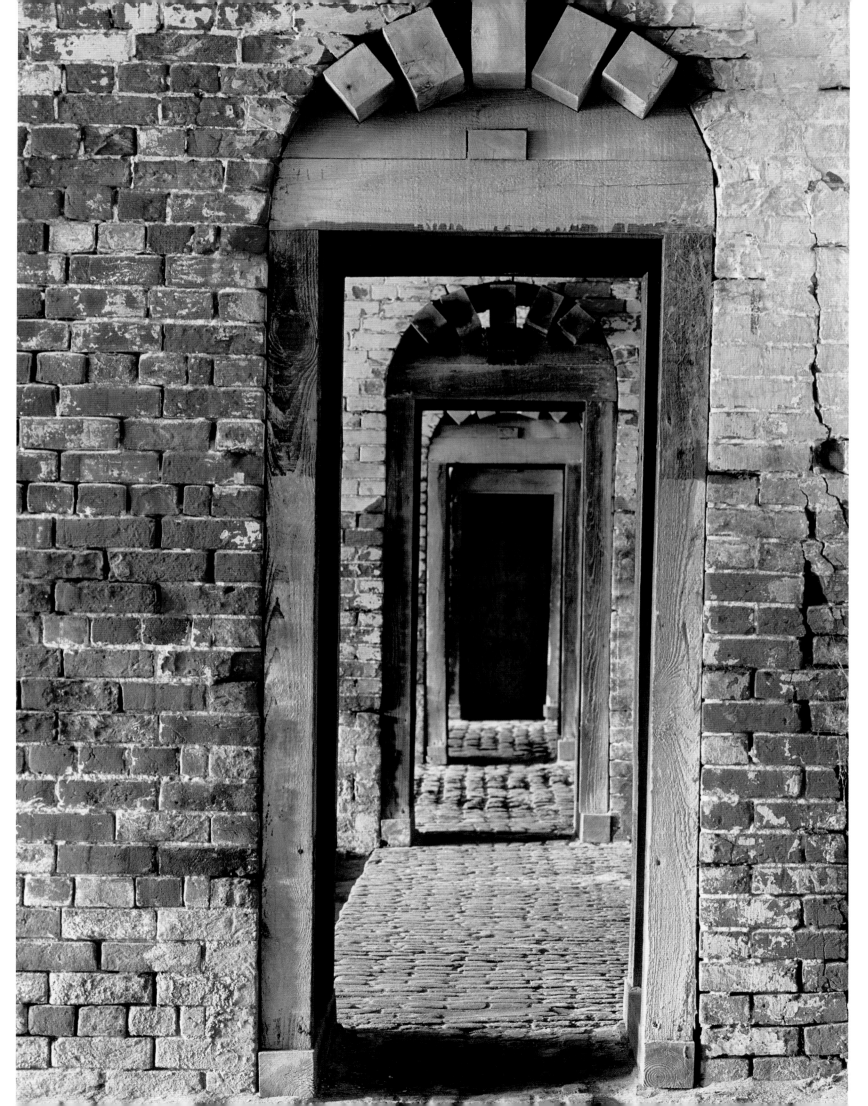

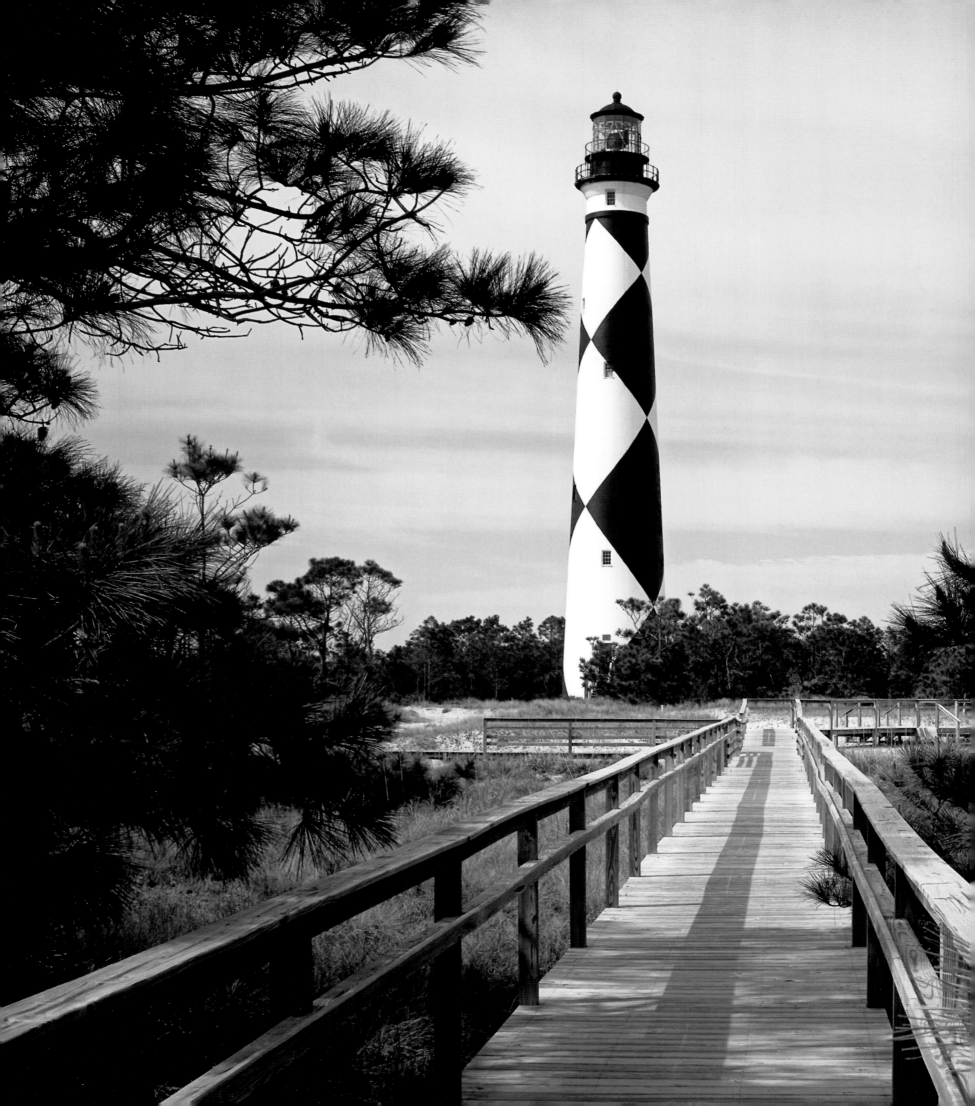

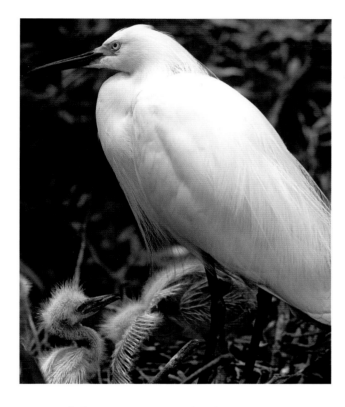

Above: Nestled in a tree at a coastal rookery, a snowy egret tends to the needs of its young.

Left: Sporting the only checkered daymark in the United States, the Cape Lookout lighthouse not only identifies itself with this distinct pattern, but also helps mariners decipher direction with its black and white diagonal checkers.

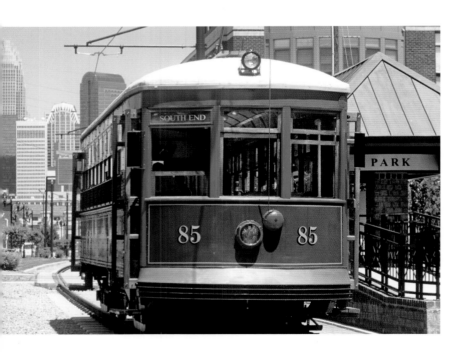

Above: Residents of Charlotte can ride the trolley and enjoy
a nostalgic means to get around town.

Right: Charlotte is North Carolina's bustling metropolitan center,
complete with a gleaming downtown skyline.

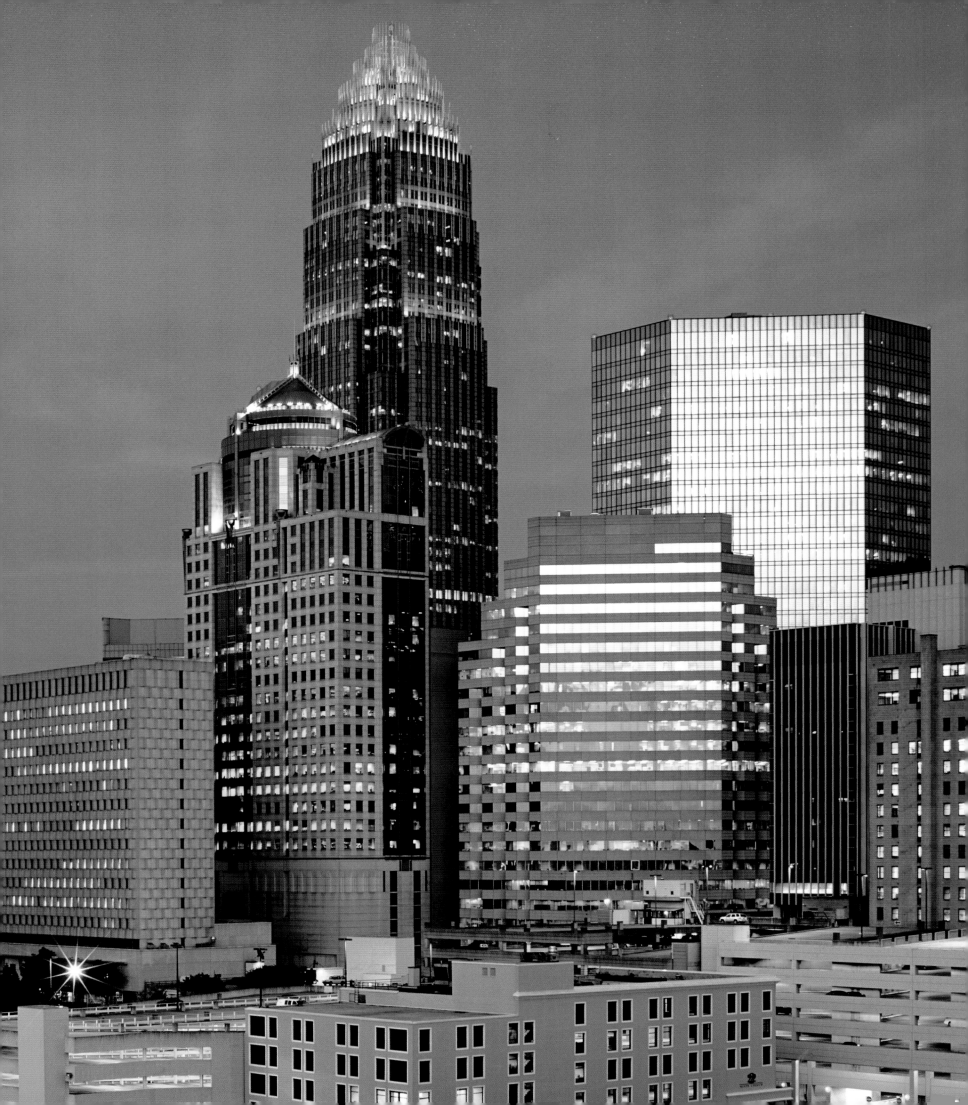

Above: Patriotic architectural details in downtown Edenton demonstrate the town's vibrant history. Edenton was the first colonial capital of North Carolina, and it is the birthplace of escaped slave Harriet Jacobs, whose memoir *Incidents in the Life of a Slave Girl* helped the abolitionist cause.

Right: Dogwood trees are a lovely spring treat, seen here in flowering abundance in Nantahala National Forest.

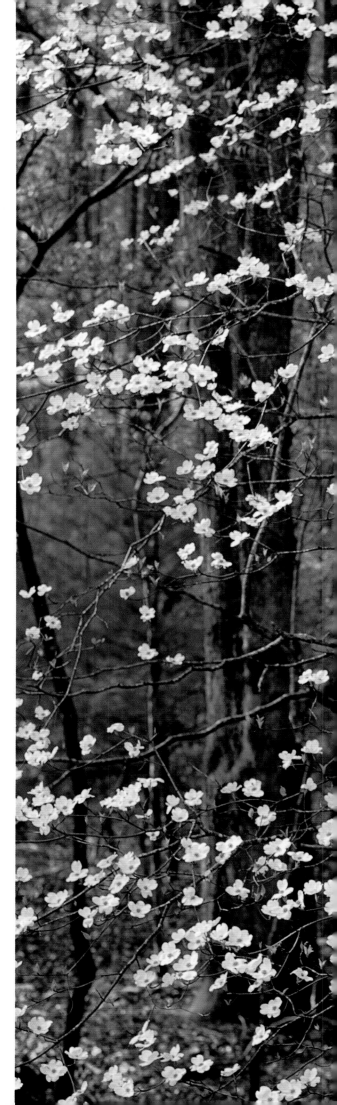

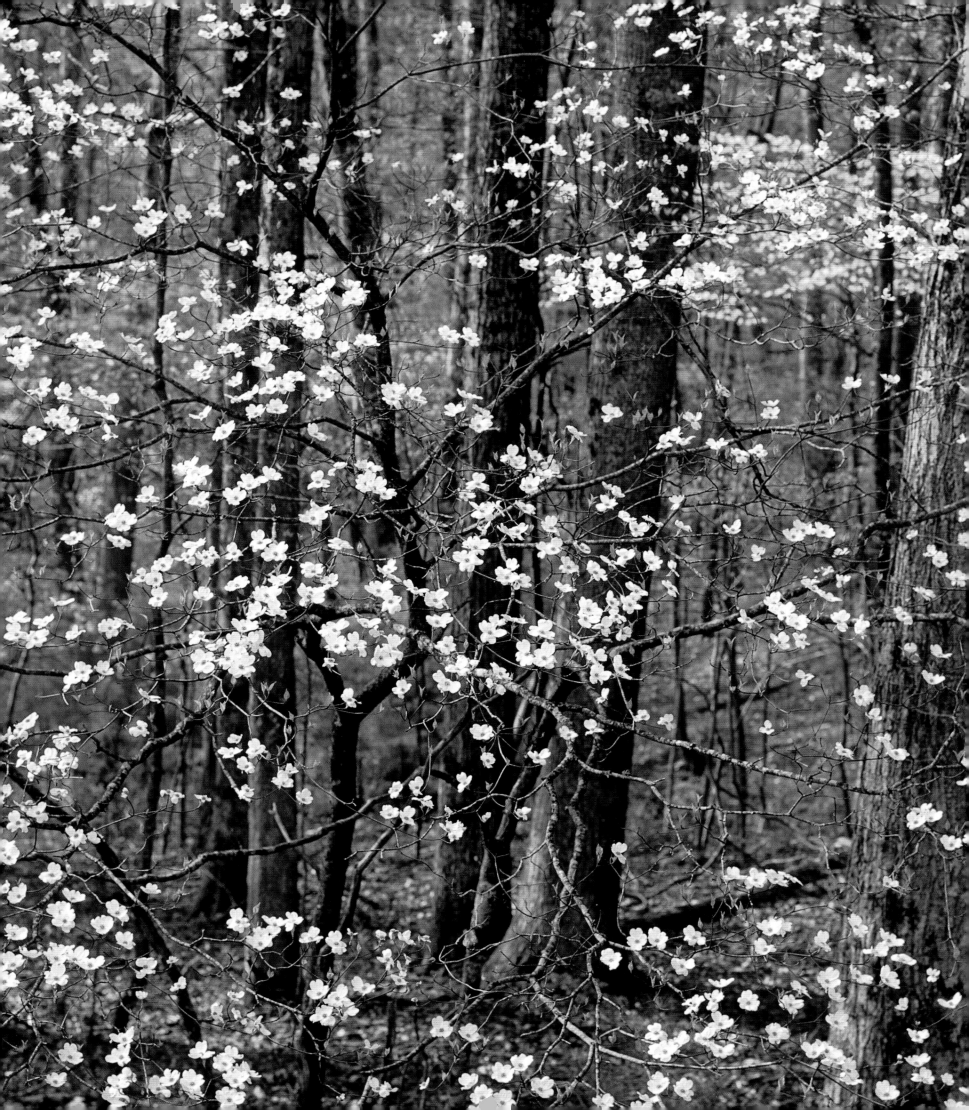

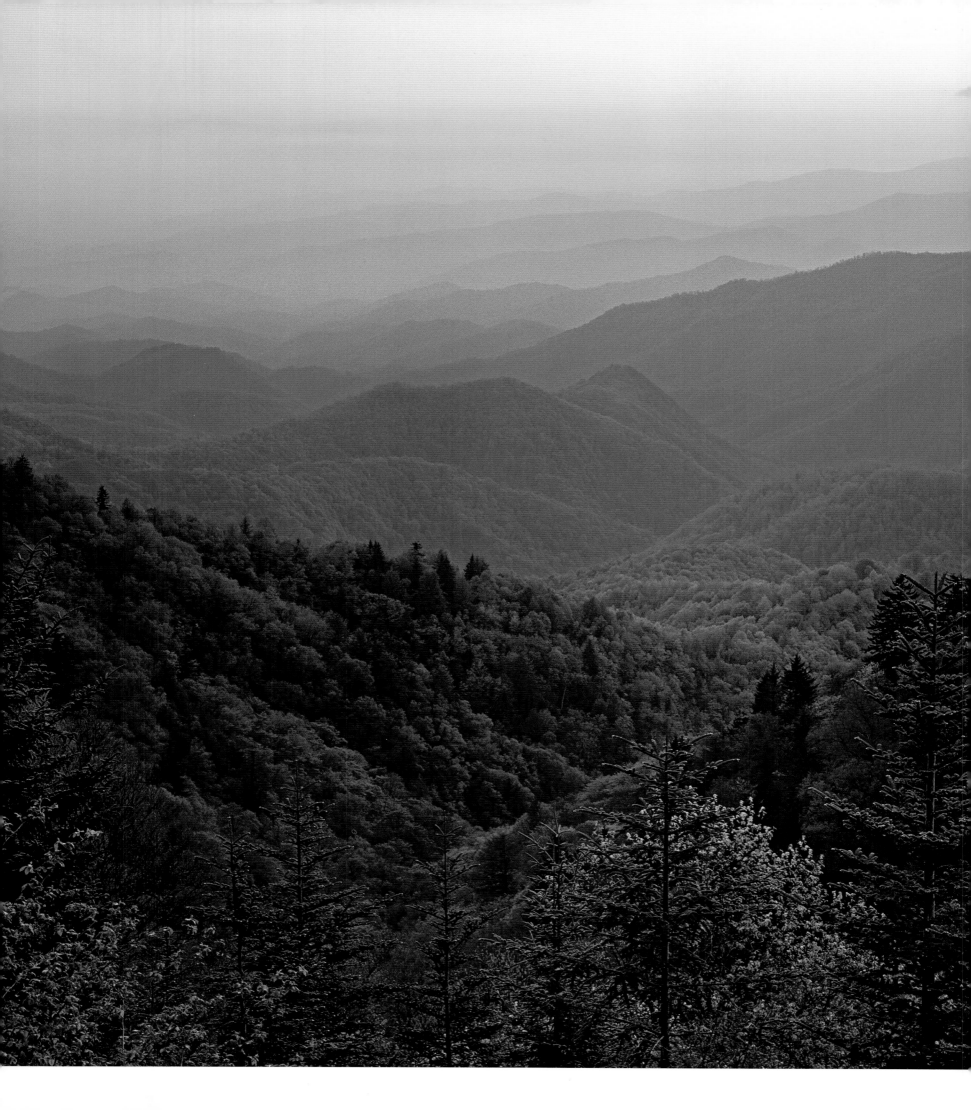

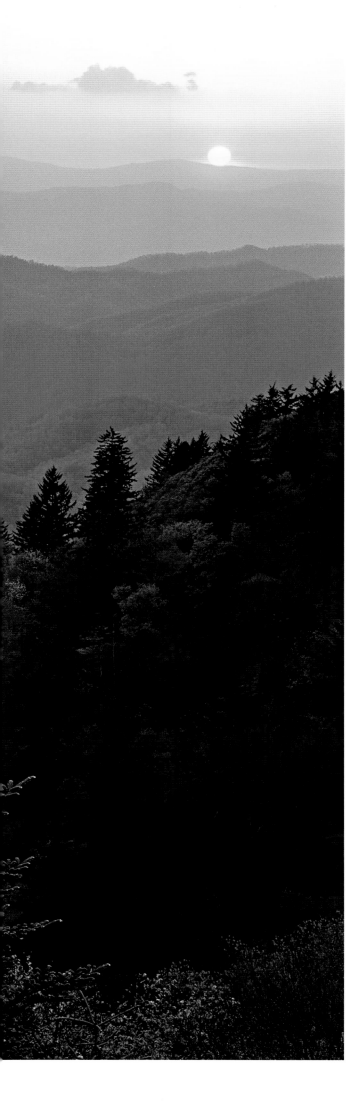

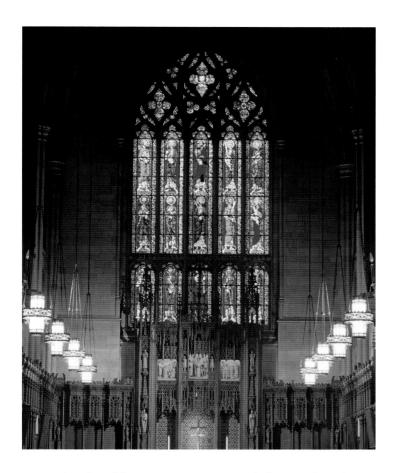

Above: Duke Chapel has seventy-seven stained glass windows featuring over 1 million pieces of glass; it is a divine landmark on the campus of Duke University in Durham.

Left: The evening view from Thunderstruck Ridge above Maggie Valley makes the Blue Ridge Mountains appear to be islands in the clouds.

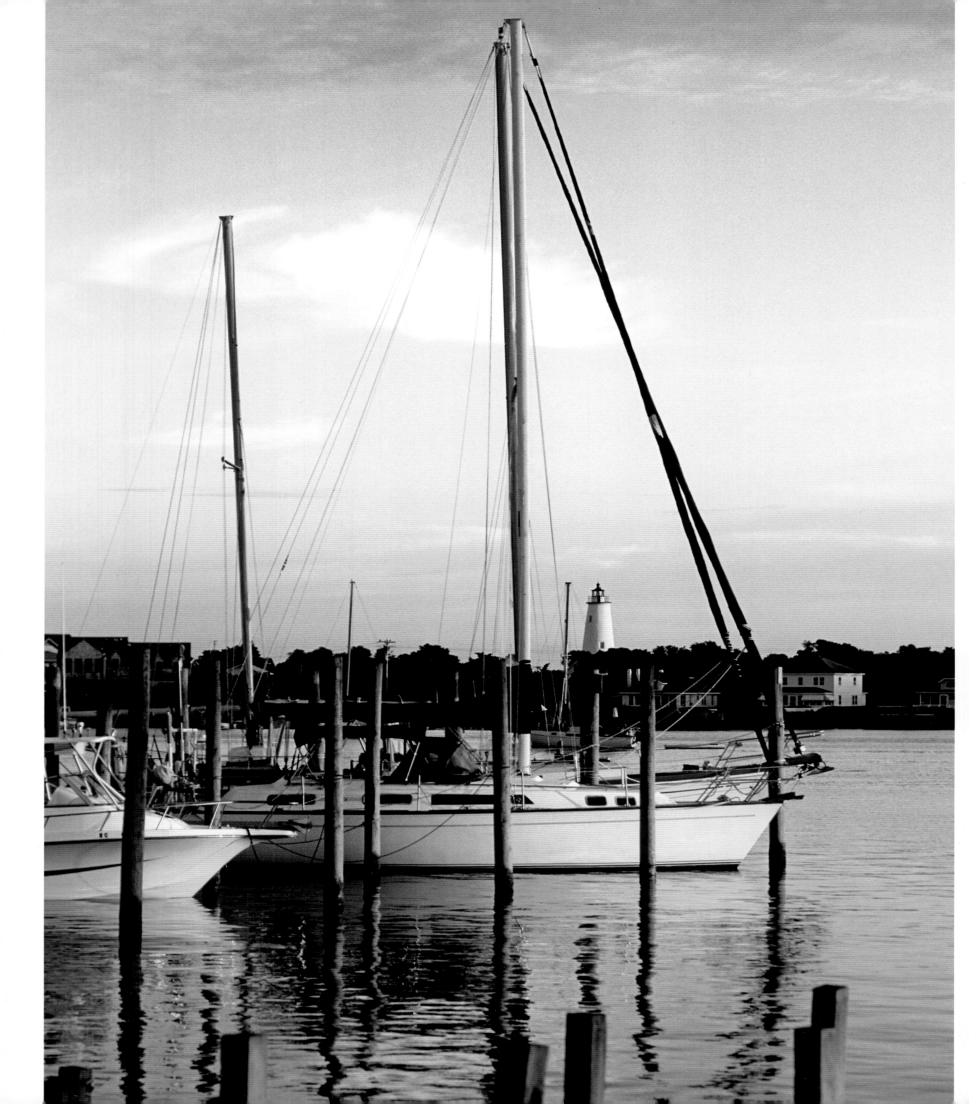

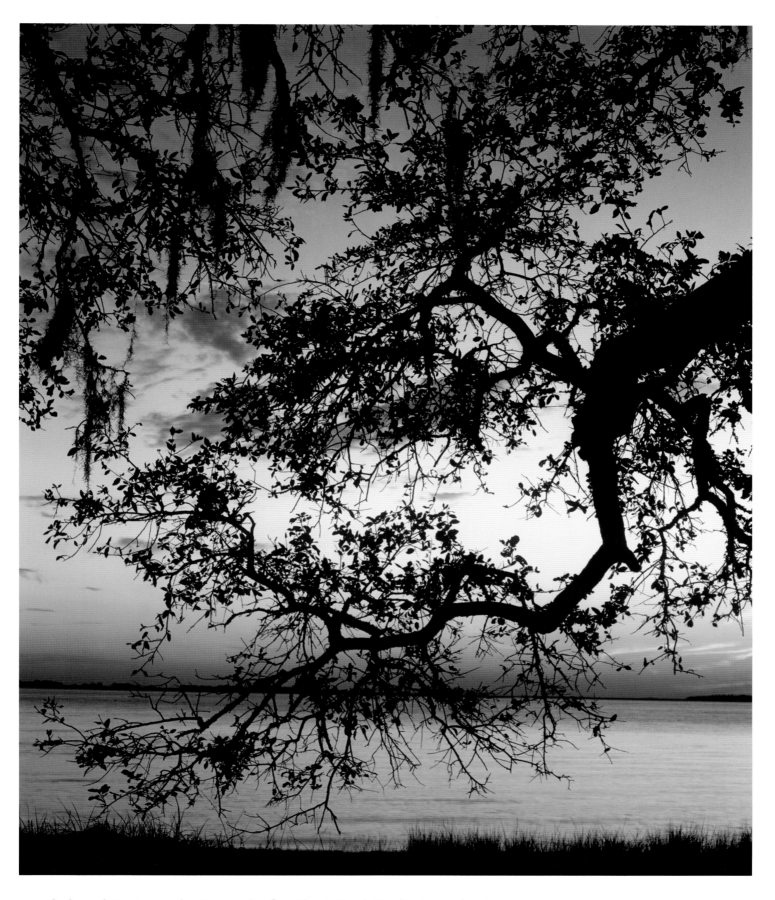

Above: The live oak is a treasured native tree that flourishes in North Carolina's coastal region. In Southport, sunrise colors alight behind this majestic specimen.

Facing page: At day's end in the Outer Banks, a glimpse of Ocracoke Lighthouse appears beyond Silver Lake Harbor in the village of Ocracoke.

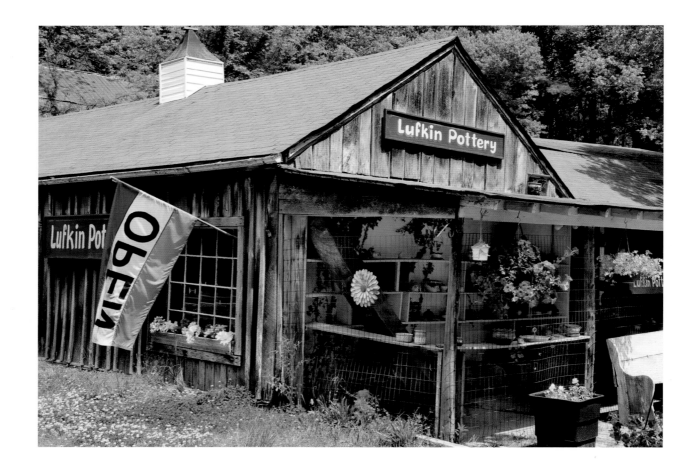

Facing page: The rocky streambed of Oconoluftee River creates its own cascading sound effects on a chilly November morning.

Right: A Frankenstein-faced jug comes alive with green and black glaze at the North Carolina Pottery Center.

Below: The town of Seagrove is known as a mecca for pottery, and visitors can see firsthand the tradition of skill and artistry that local potters continue to practice at their rustic workshops.

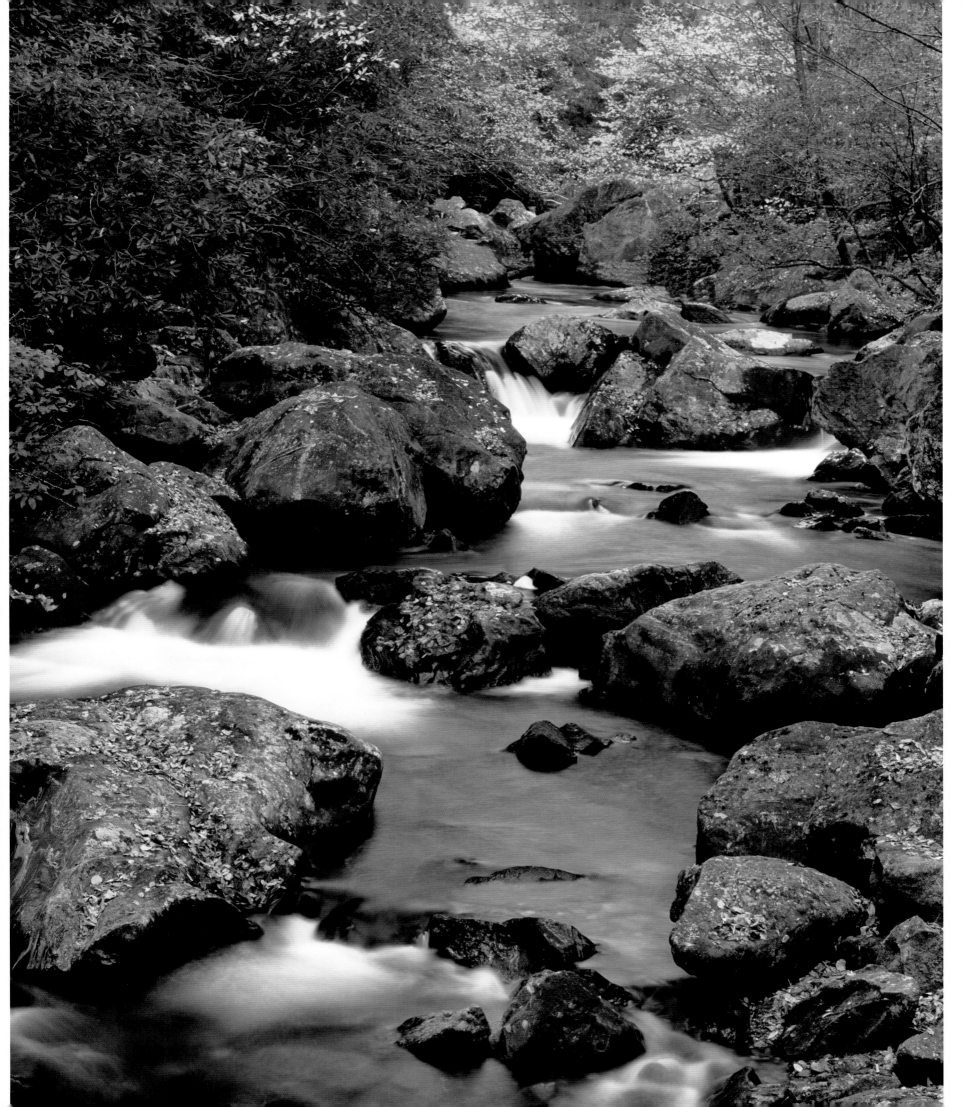

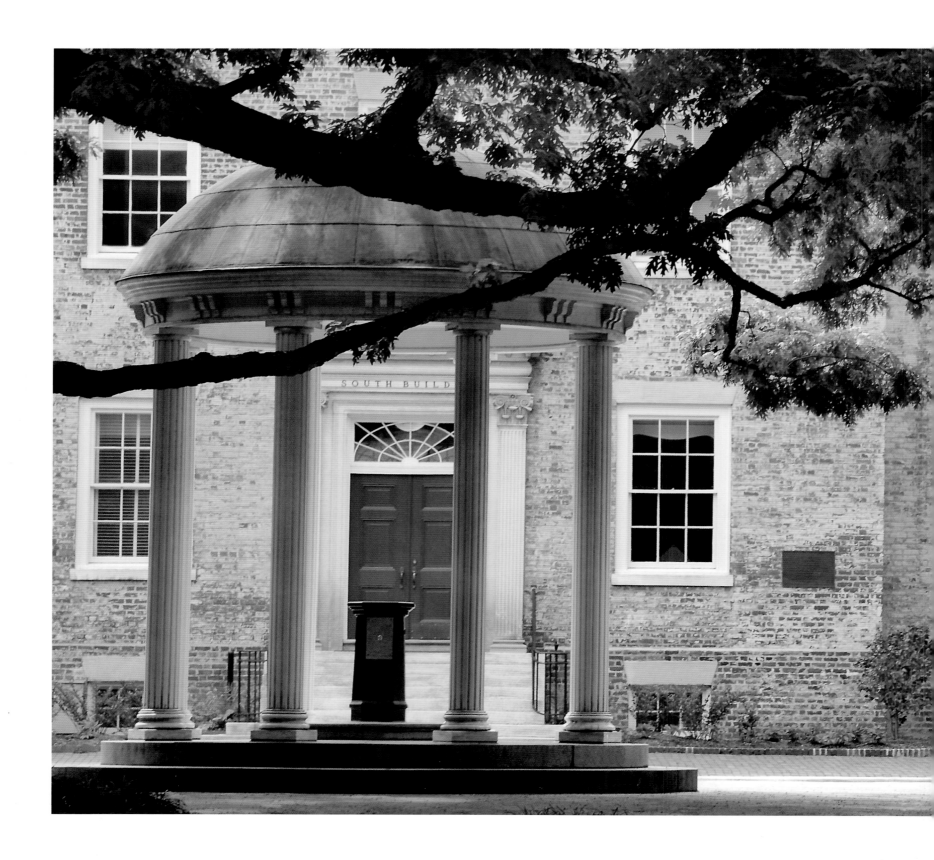

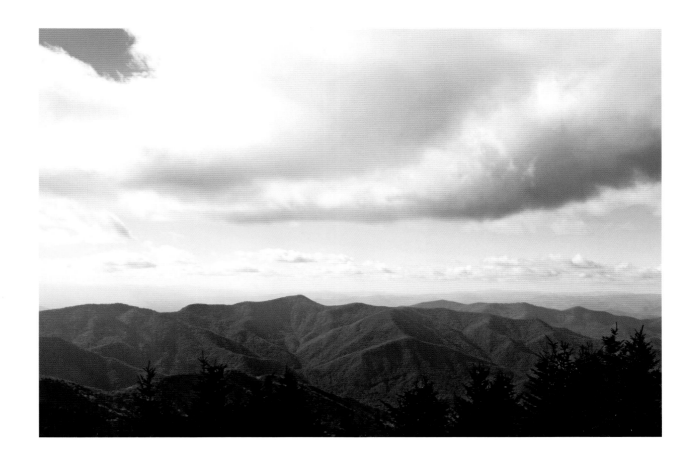

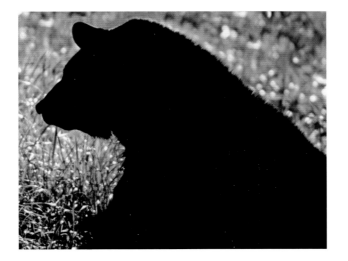

Above: From the top of Mount Mitchell, everything in view can be considered "down below." At 6,684 feet, it is the highest point not only in North Carolina, but also in any state east of the Mississippi River.

Left: The unmistakable silhouette of a black bear is visible in the shadows of a field in Great Smoky Mountains National Park.

Far left: The Old Well is a storied landmark and symbol of the University of North Carolina at Chapel Hill. A drink from it on the first day of classes is said to give students good luck. The decorative gazebo, inspired by the gardens of Versailles, was erected in 1897.

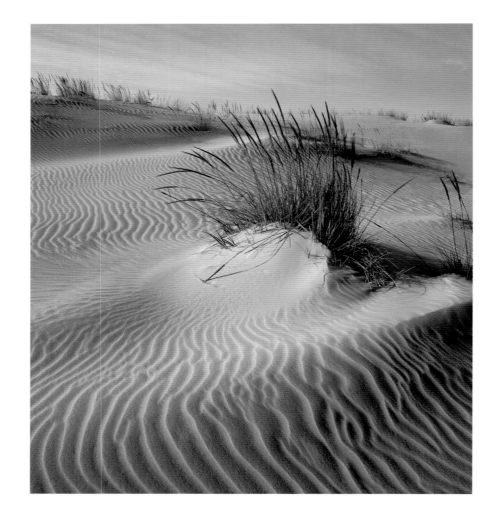

Above: Early sunshine highlights the fine, wind-sculpted details on a sand dune at Jockey's Ridge.

Right: A boat steams through the waters of Oregon Inlet and leaves sun-speckled ripples in its wake. Behind the boat rises Herbert C. Bonner Bridge, which offers a 2.7-mile car ride across the inlet.

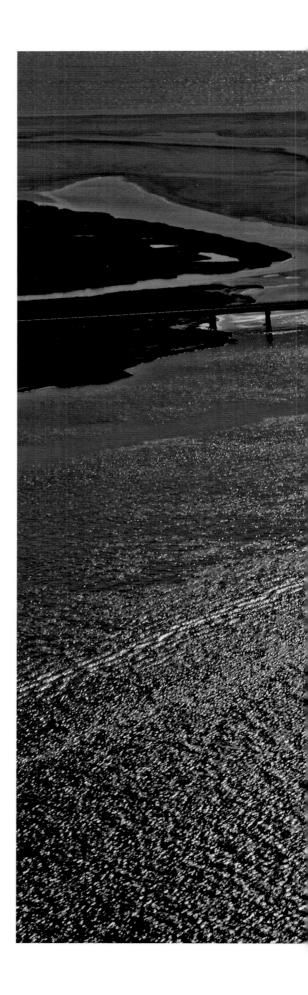

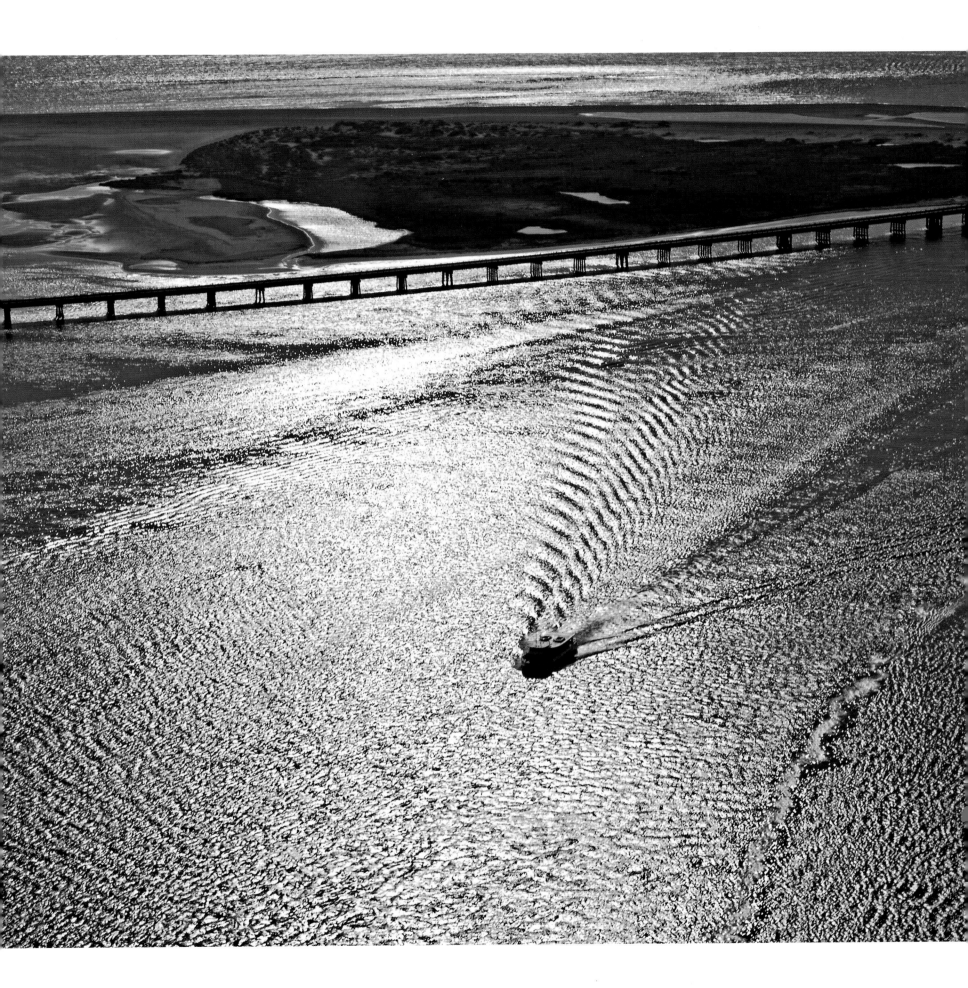

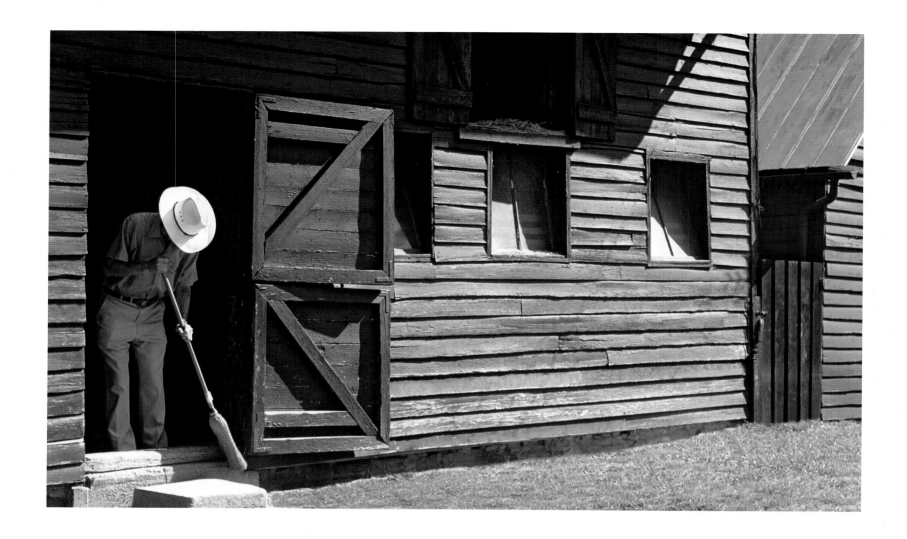

Above: Morning chores are easily swept away at Carl Sandburg Home National Historic Site, the home of the famous author, folk singer, and social activist from 1945 until his death in 1967.

Right: The Yadkin Valley is a notable winemaking region located in the foothills of the Blue Ridge Mountains. With a winemaking history stretching back to the 400-year-old Mother Vine on Roanoke Island, North Carolina is today home to more than 400 vineyards.

Facing page: Linville Falls is a breathtaking sight after a short hike up Erwins View Trail, found just off the Blue Ridge Parkway.

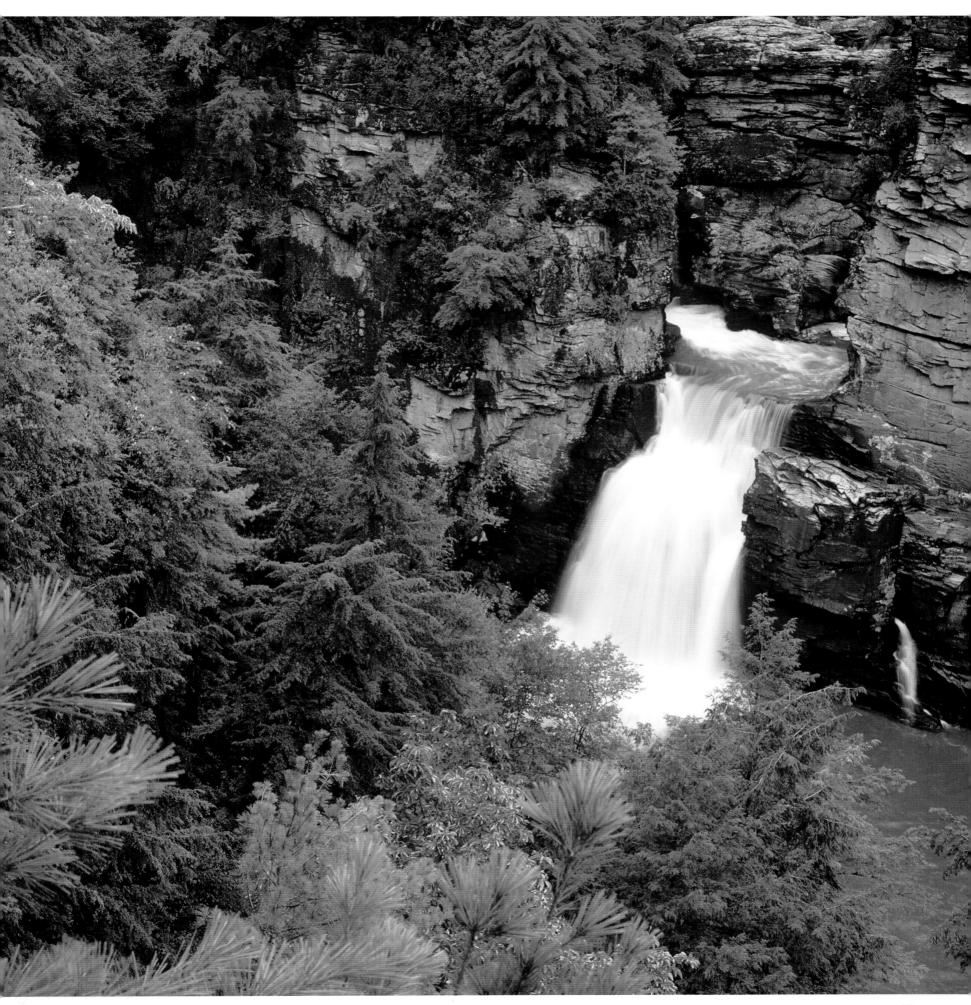

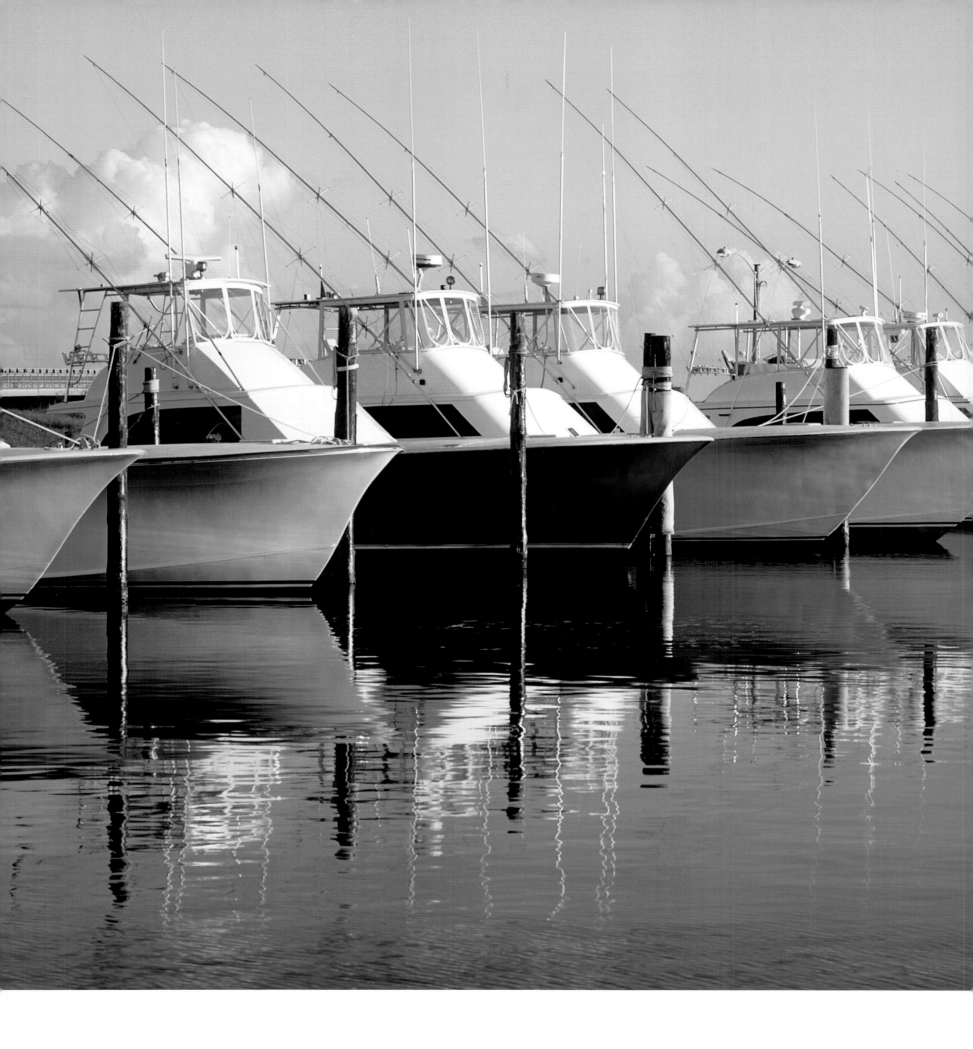

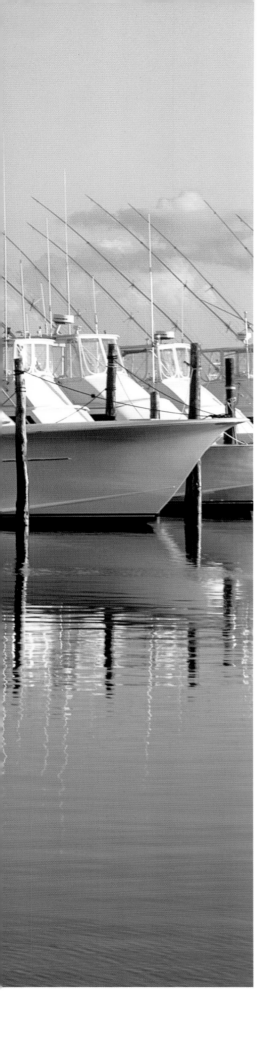

Above, top: The entrance to the Billy Graham Library is a reminder of the life and mission of "America's Pastor," who grew up on this former dairy farm near Charlotte.

Above, bottom: Shultz House, home of the town's shoemaker in the early nineteenth century, is a charming sight in red and white along Main Street in Old Salem.

Left: A safe harbor shelters an armada of pleasure boats at Oregon Inlet. The inlet was formed in 1846 by a hurricane that separated Bodie Island from Pea Island, and it's named for the first ship to navigate the new opening.

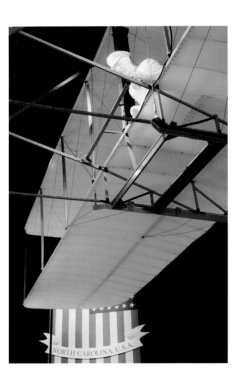

Facing page: A monument atop a seaside dune at Kitty Hawk celebrates the triumph of Ohio bicycle mechanics Wilbur and Orville Wright, the first people to achieve sustained human flight.

Right: A full-size replica of the *Wright Flyer* seems to flit overhead at the North Carolina Museum of History in Raleigh. It commemorates the Wright Brothers' historic first flight on December 17, 1903.

Below: An eastern view from above Bald Head Island reveals the rich colors of the salt marsh with blue tidal creeks meandering toward the sea.

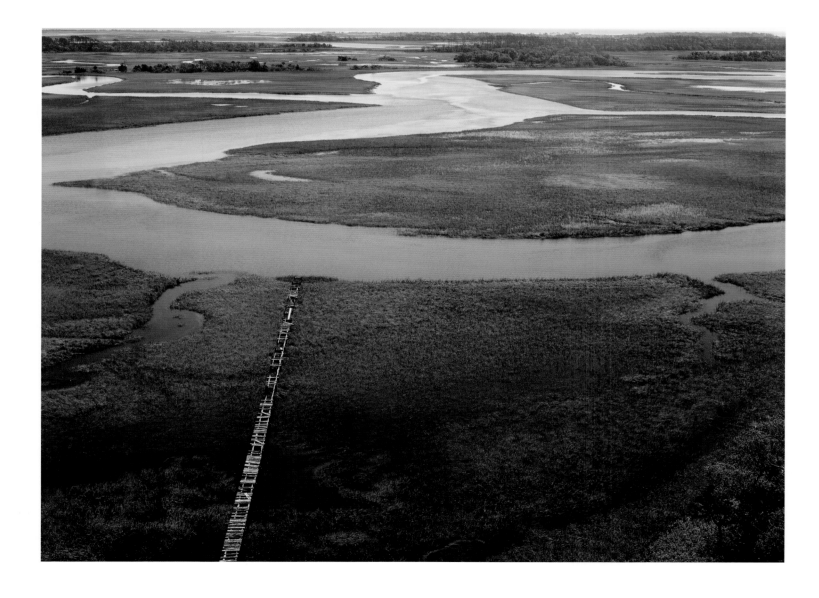

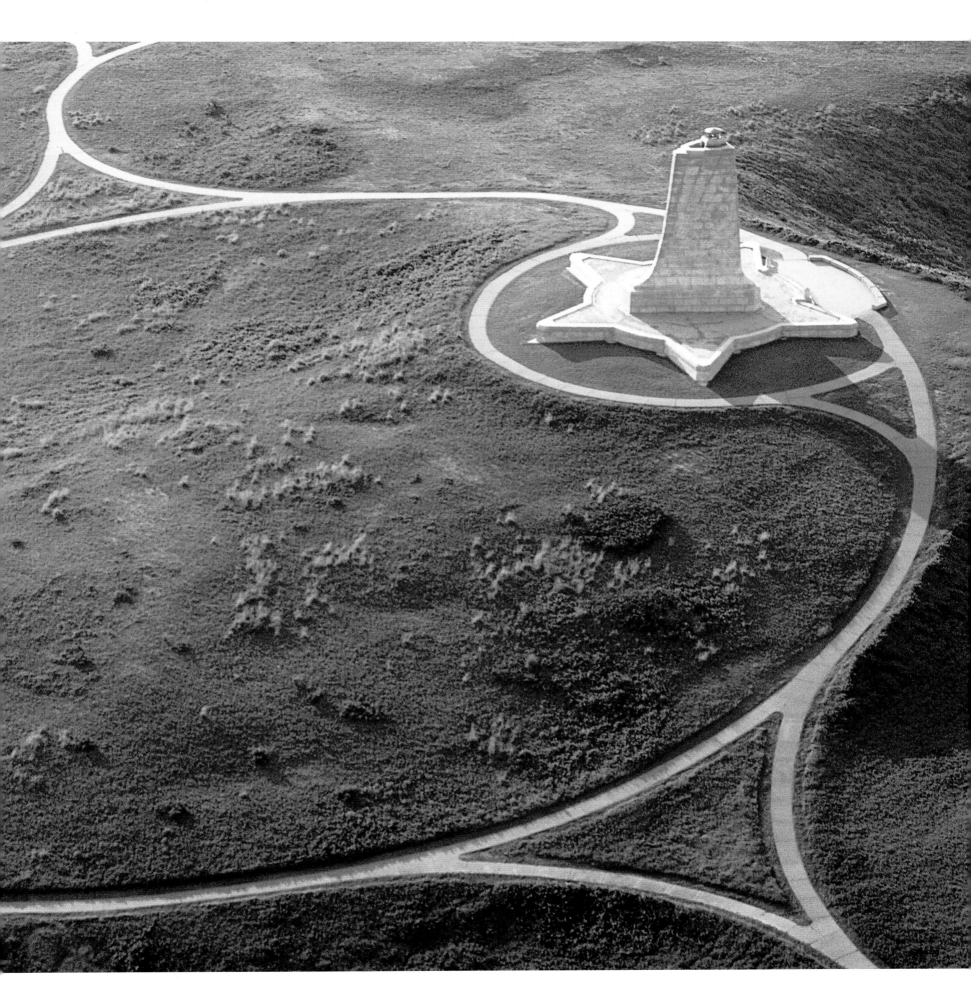

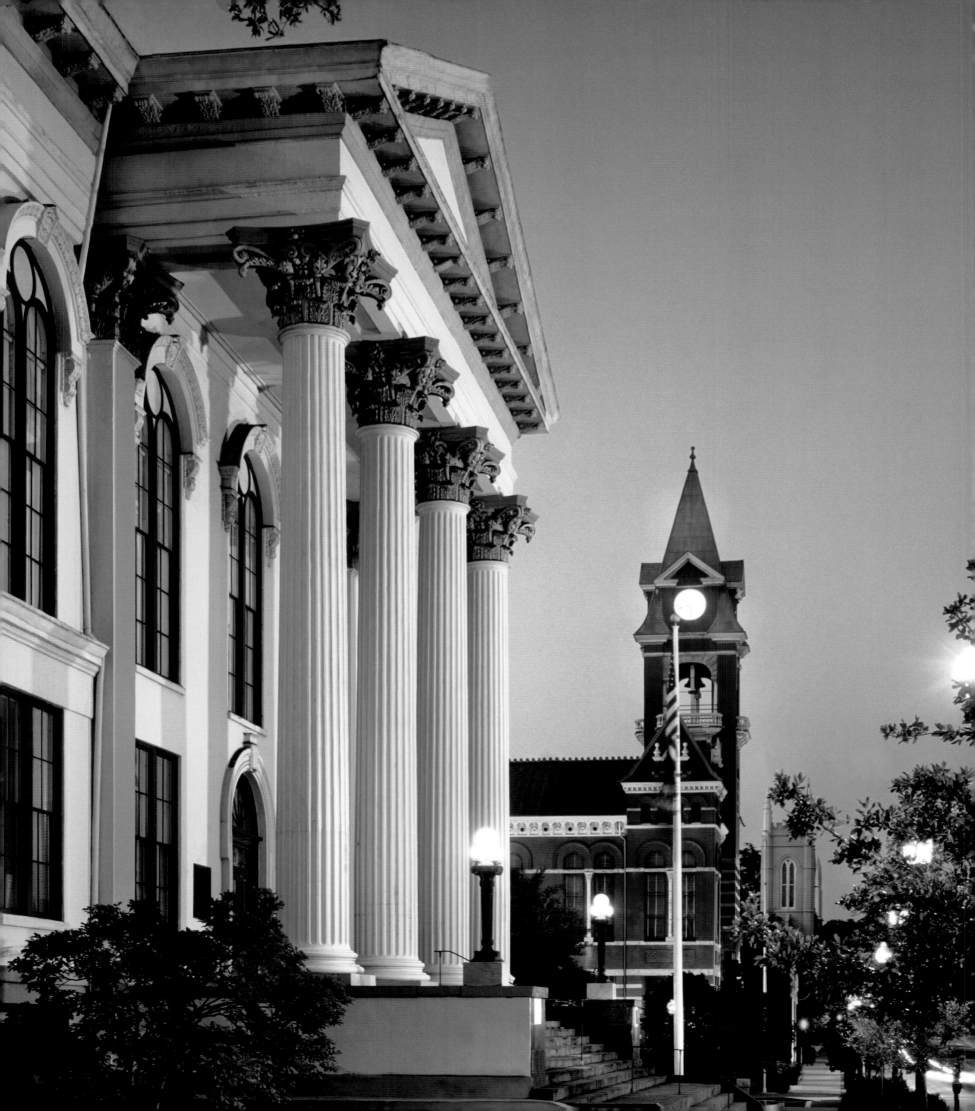

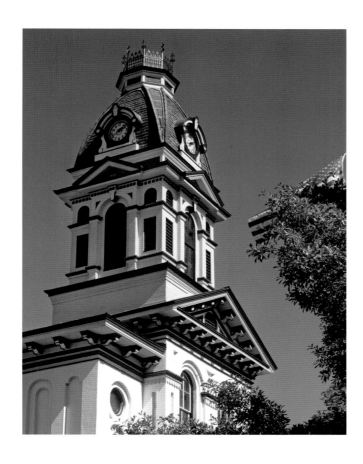

Facing page: Thalian Hall is a restored Wilmington landmark that remains a vital cultural center for the arts. The edifice, which at its opening in 1858 served as the city hall, a library, and an opera house, is listed on the National Register of Historic Places.

Left: The old Cabarrus County Courthouse is a handsome sight in downtown Concord.

Below: Revolutionary War hero General Nathanael Greene surveys the battlefield astride his stallion at Guilford Courthouse National Military Park.

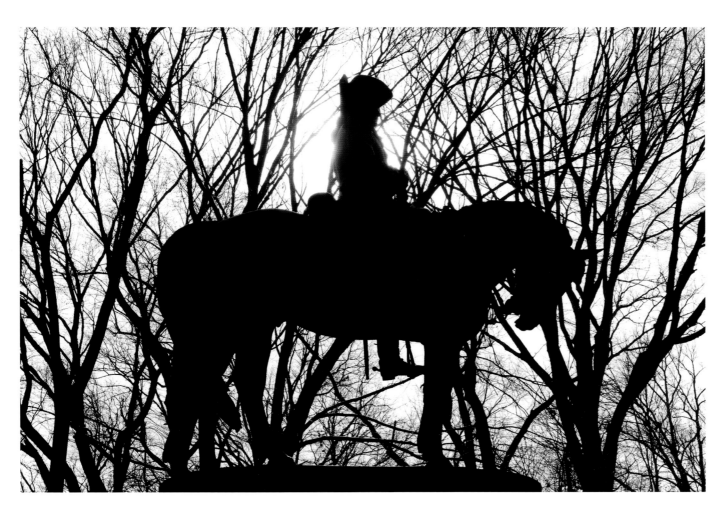

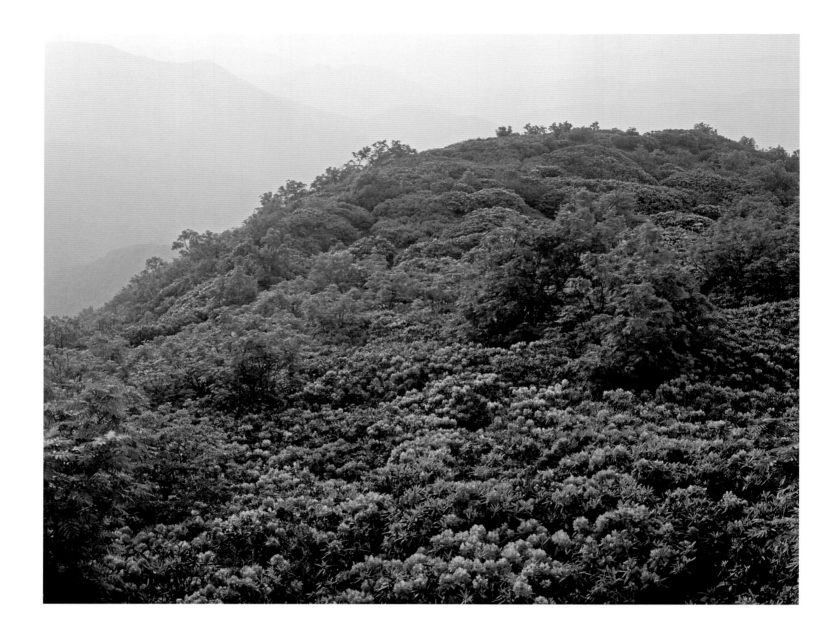

Above: In early summer, blooming Catawba rhododendron creates a mountain-top paradise at Craggy Gardens in the Blue Ridge Mountains.

Right: Statues representing Apollo, Venus, Diana, and Jupiter can be found in the Sunken Garden at the lovely Elizabethan Gardens in Manteo.

Facing page: A rustic cabin appears out of the fog on a leisurely drive along the Blue Ridge Parkway.

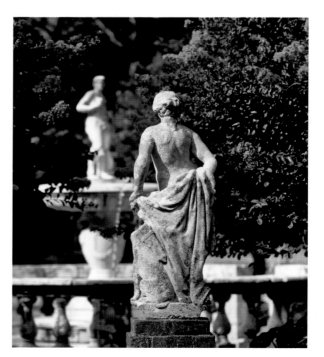

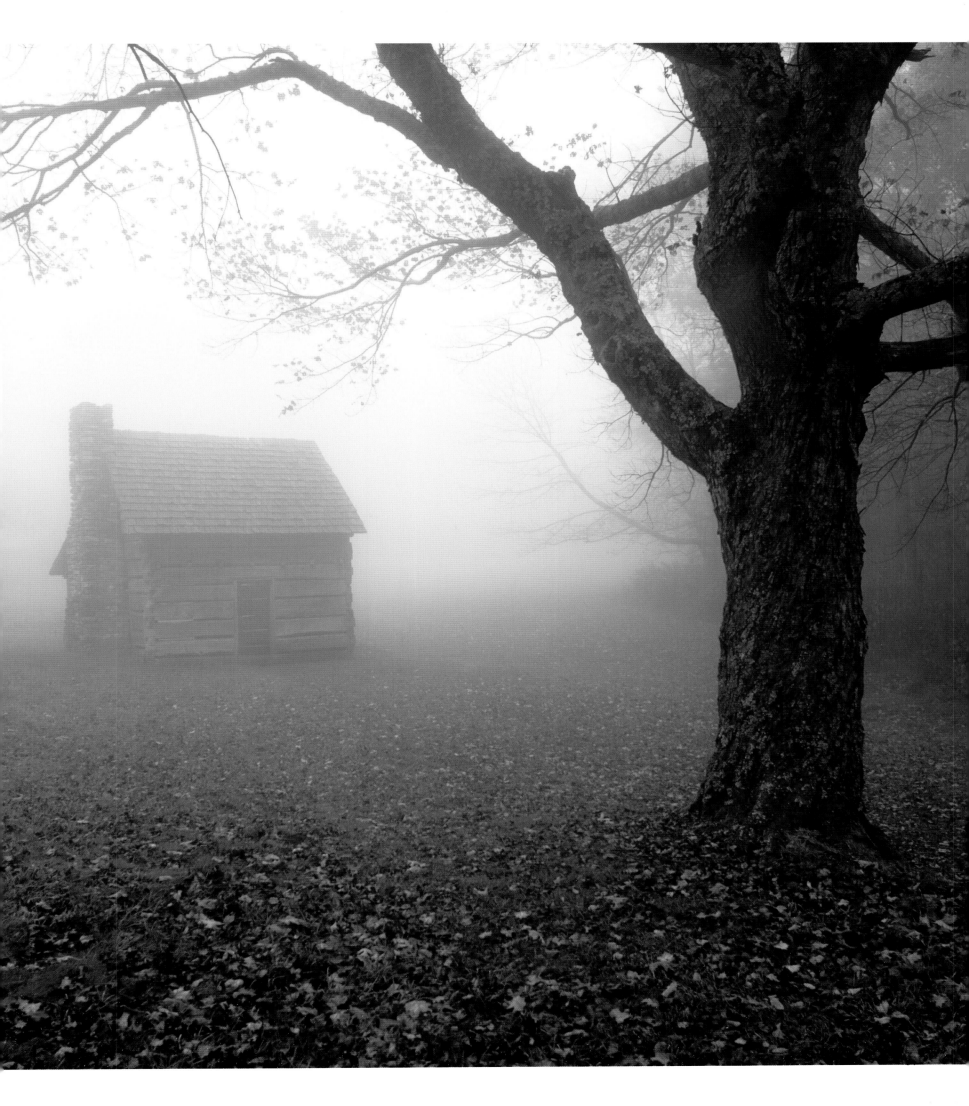

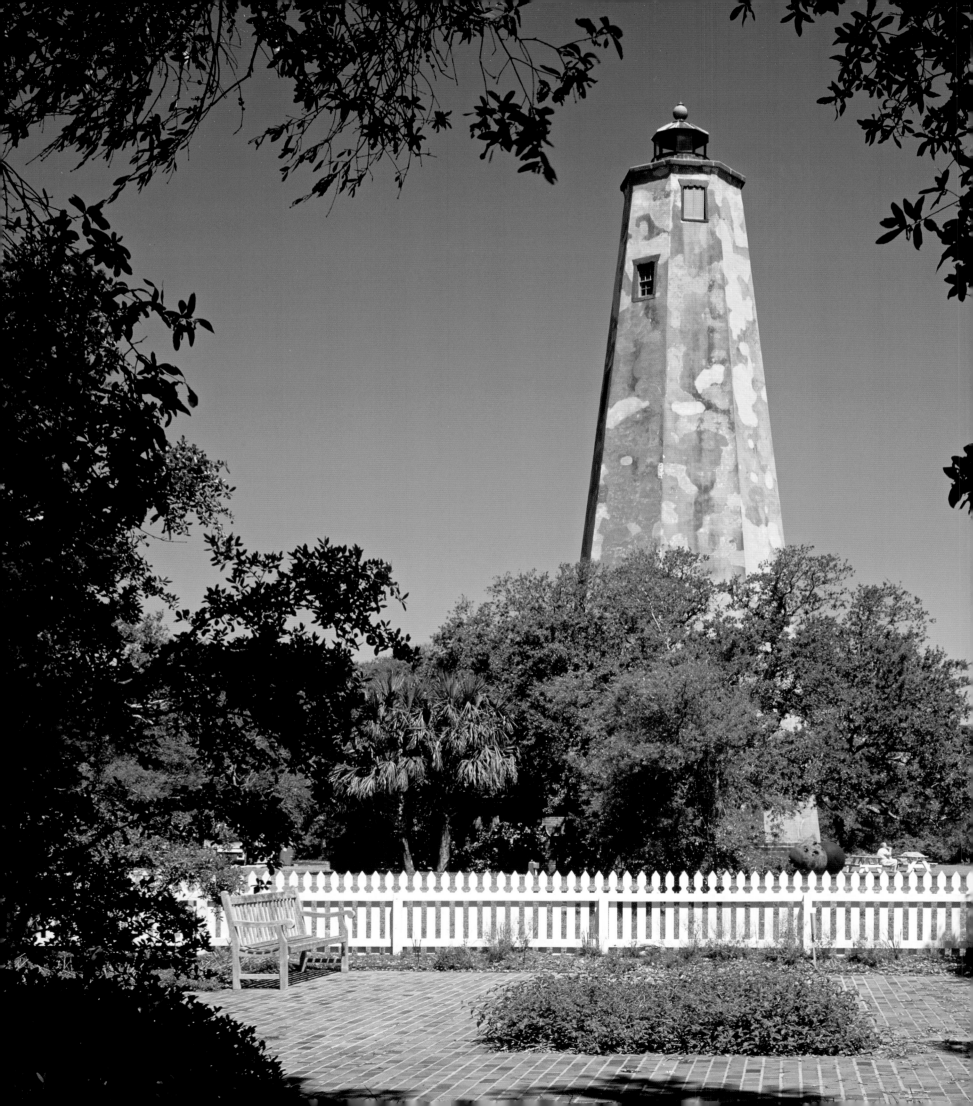

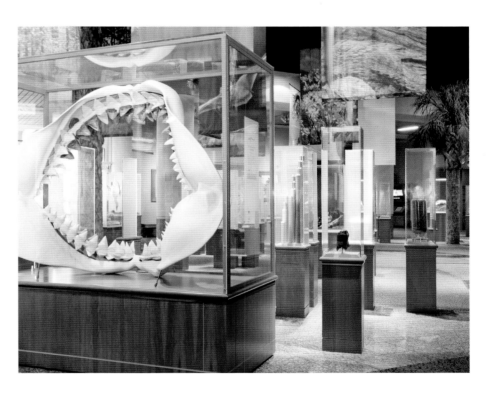

Above: The North Carolina Museum of Natural Sciences features this permanent exhibit, which showcases the state's jaw-dropping natural treasures.

Left: Bald Head Island Lighthouse, known affectionately as "Old Baldy," is the oldest lighthouse still standing in the state of North Carolina.

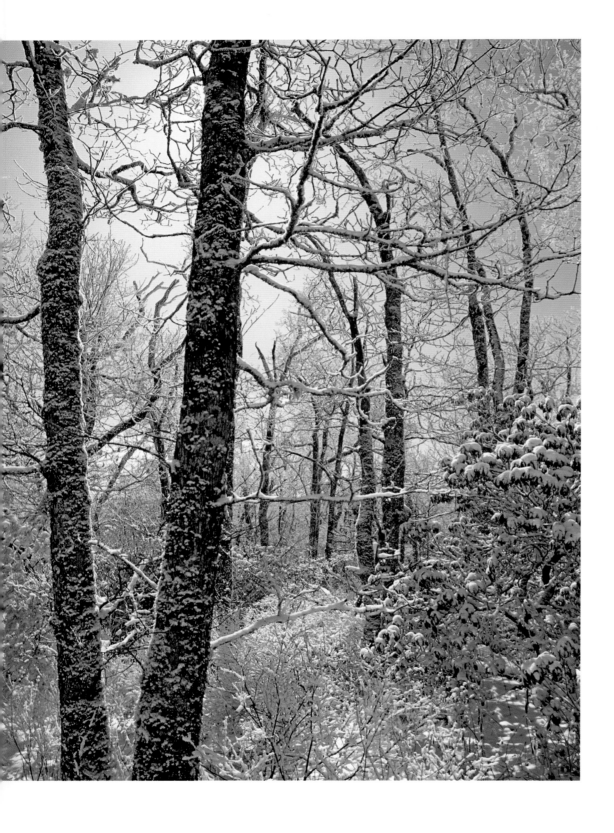

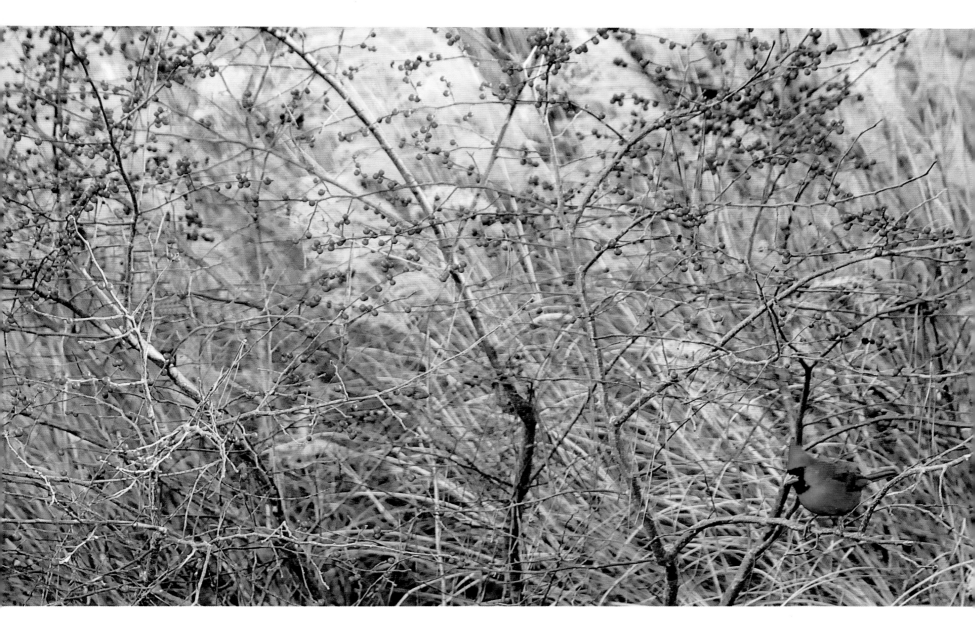

Above: A male cardinal matches color with his Valentine's Day snack of winterberries in a North Carolina garden.

Facing page: Warm sunlight filters through a frosty mountain forest after a late winter storm. Some of North Carolina's largest snowfalls have come in the month of March.

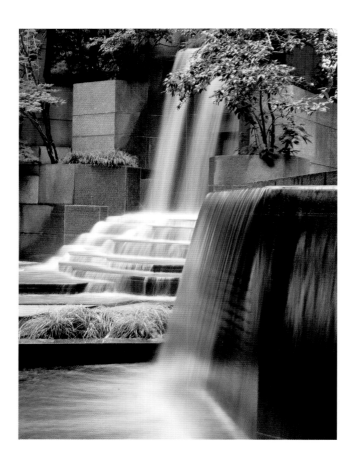

Facing page: In the colonial-style gardens at the Burgwin-Wright House in Wilmington, a bricked dipping pool is a welcome place for reflection on a steamy Southern afternoon.

Right: On the square in Charlotte, the refreshing spray of a fountain is a quiet place for a moment away from a busy day in the city.

Below: "The World's Largest Chest of Drawers" is a thirty-two-foot-tall landmark, complete with dangling socks, which celebrates High Point's worldwide fame as a capital of furniture-making and hosiery.

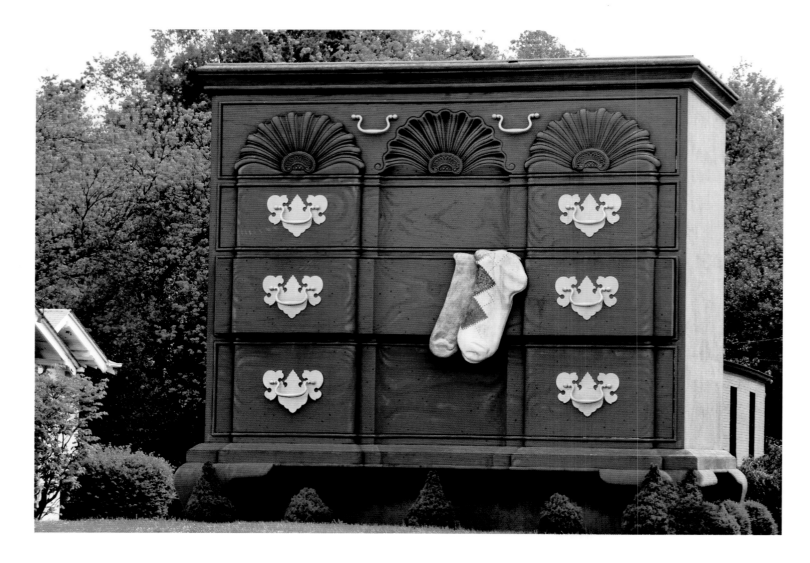

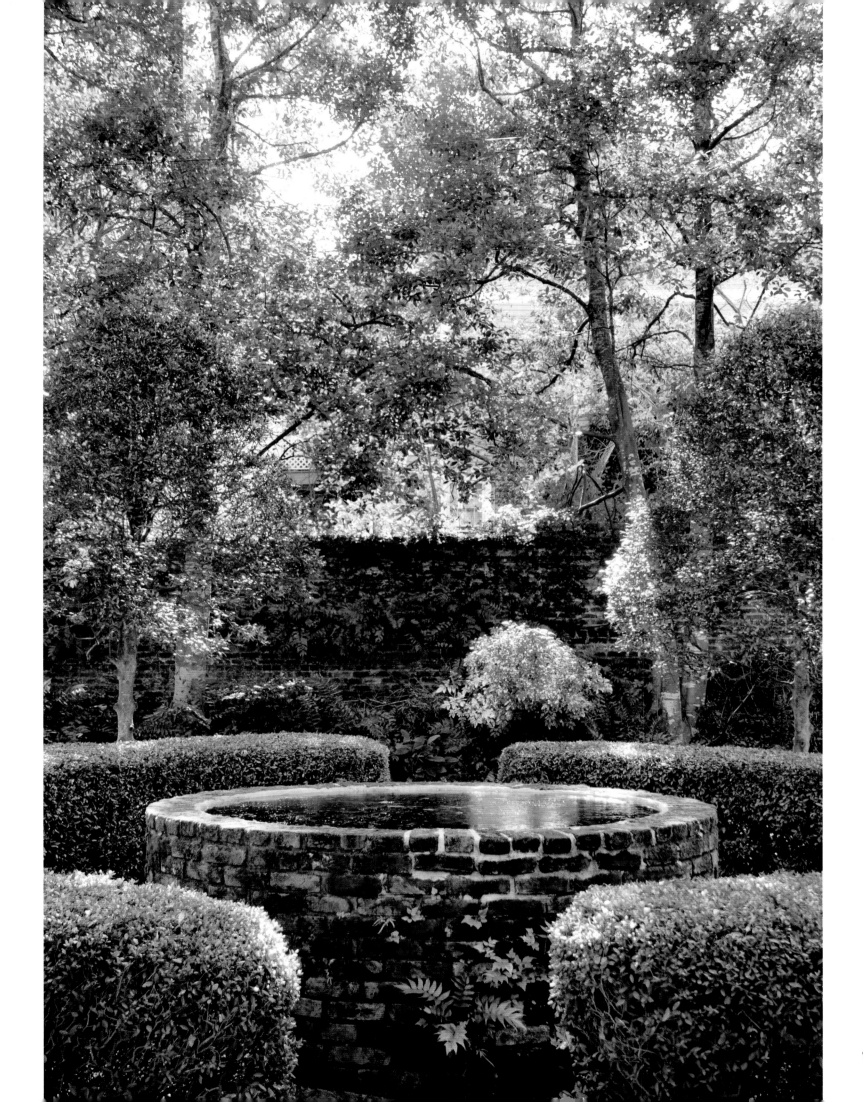

Left: The charming town green in Edenton offers a view of watery pleasures on Albemarle Sound.

Below: Weathered by the years and the elements in Edenton, time cannot diminish the devotion felt for a child remembered in stone.

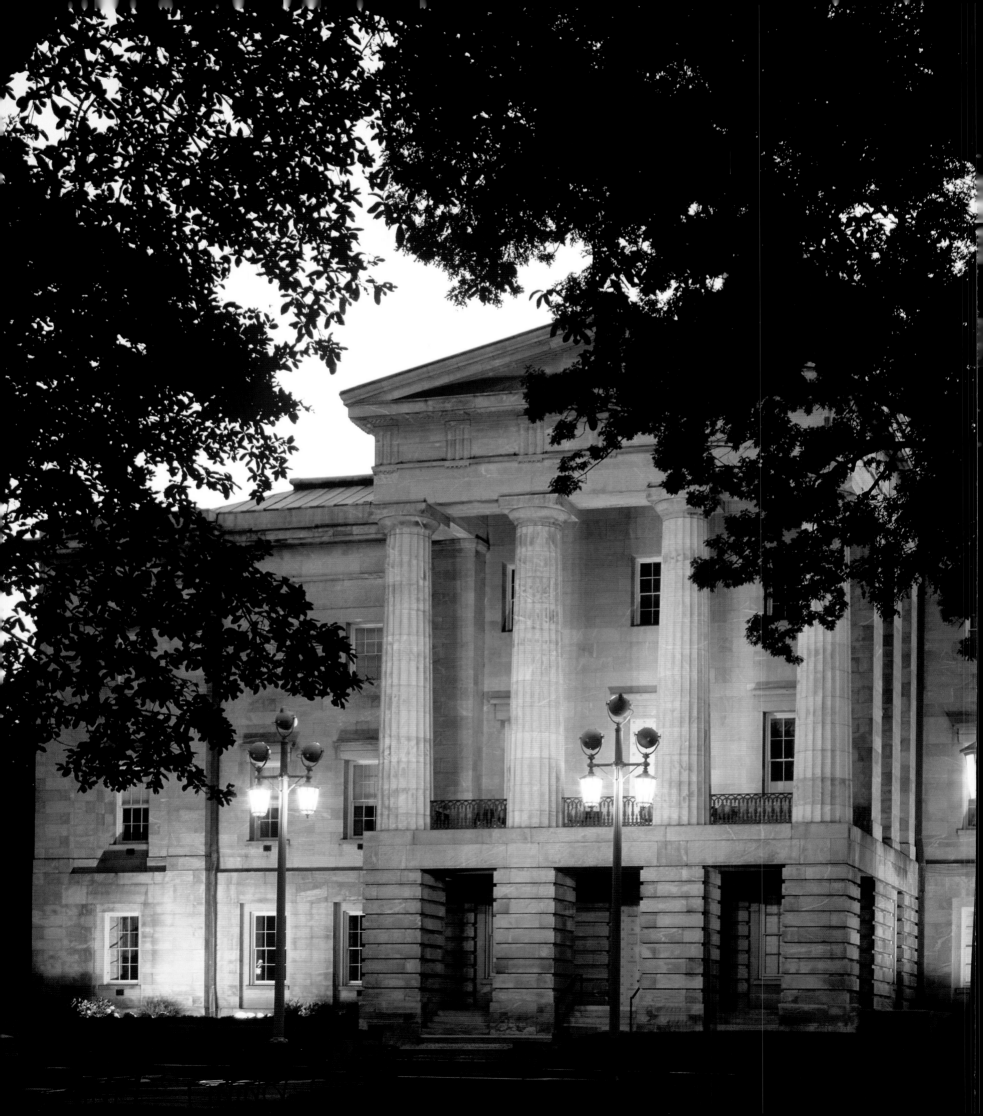

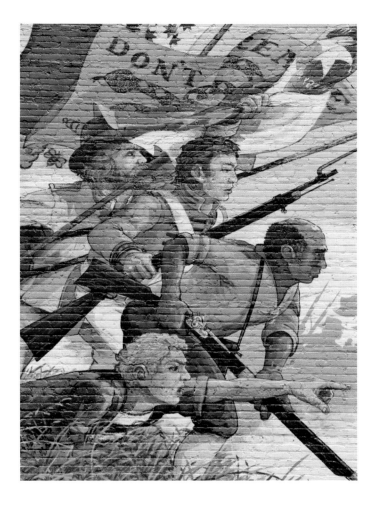

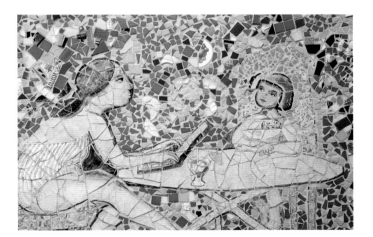

Above, top: This mural in Goldsboro honors those who fought and sacrificed in conflicts throughout American history.

Above, bottom: In downtown Charlotte, a mosaic depicts a happy moment between a mother and daughter.

Left: The North Carolina State Capitol, a Greek Revival edifice opened in 1840, glows in the early evening twilight.

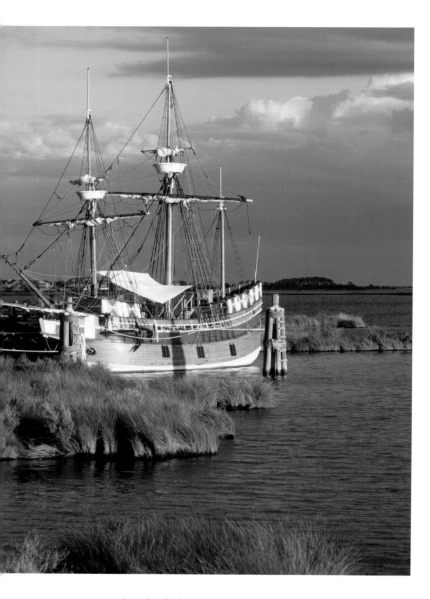

Above: The *Elizabeth II* was modeled after the sailing ships in Sir Walter Raleigh's fleet, which brought colonists to Roanoke Island in 1587. The Roanoke Colony, along with the first English child born in the New World, Virginia Dare, disappeared without a trace between 1587 and 1589.

Right: A view through the salt marsh shows distant seaside dunes and a patient great blue heron on the hunt for its next meal.

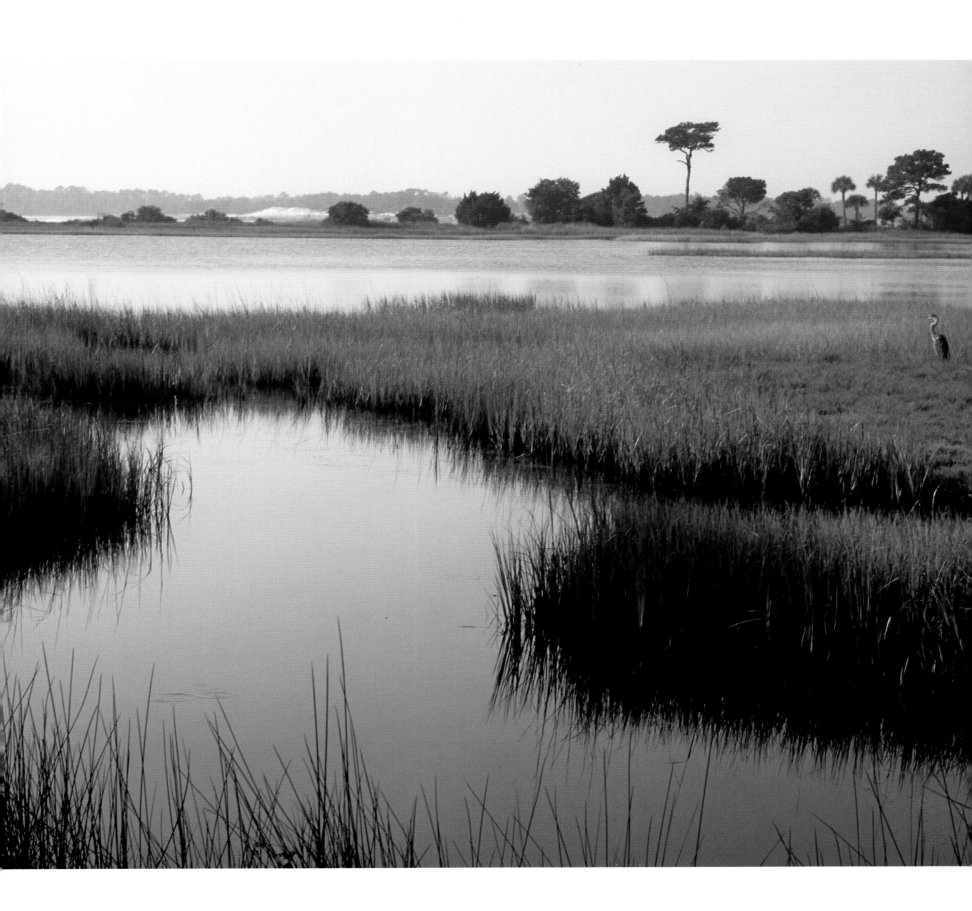

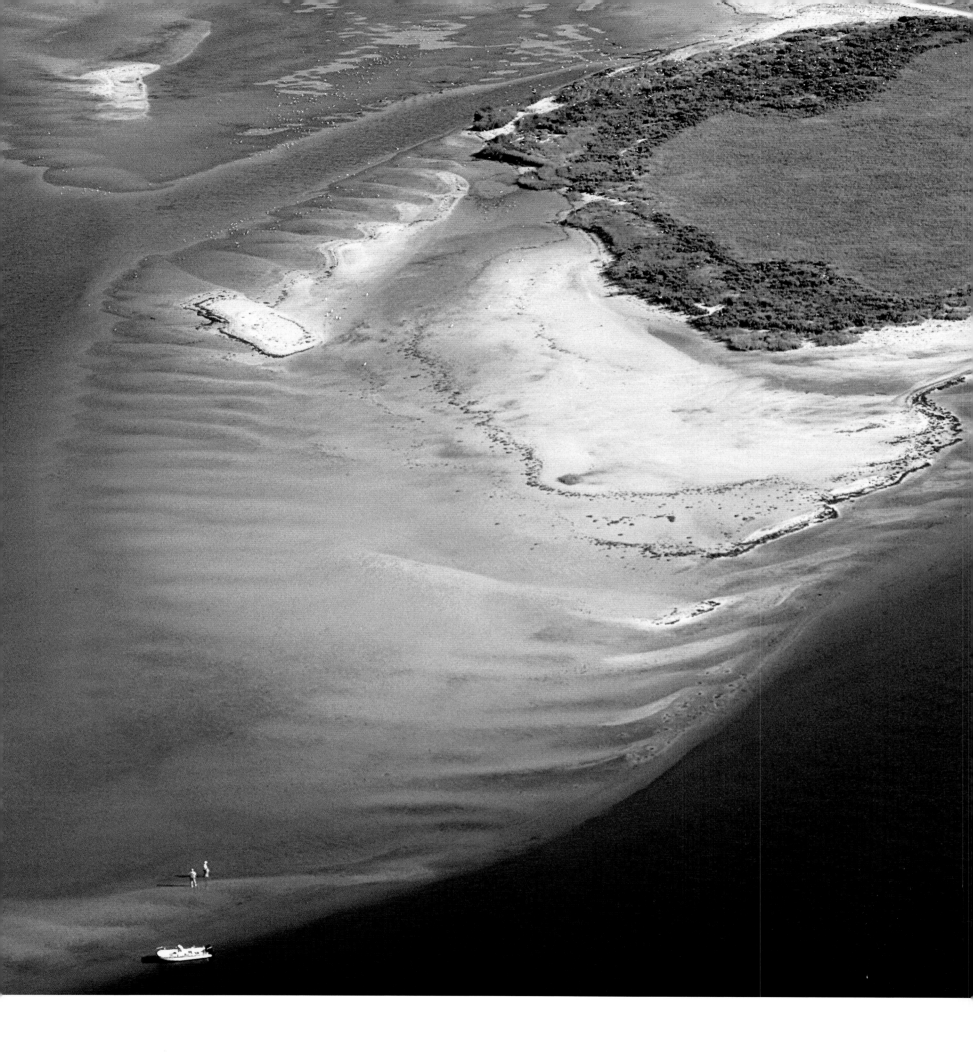

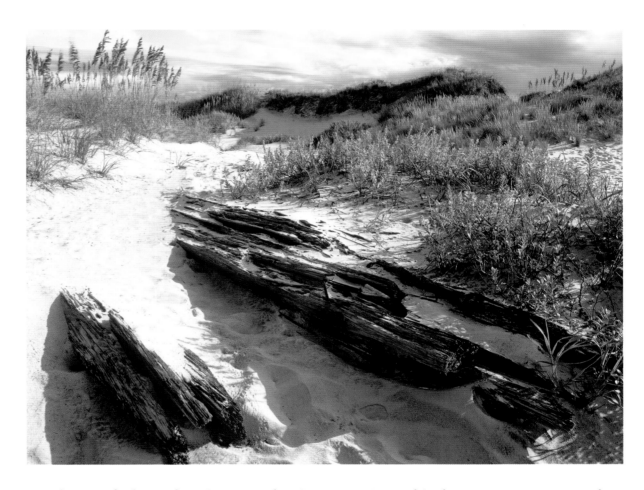

Above: The ruins of a shipwreck on Coquina Beach at Cape Hatteras National Seashore are a testament to more than 1,000 vessels that have met their doom along the shores of the Outer Banks—the "Graveyard of the Atlantic."

Left: Two explorers leave their boat behind and wander onto an uninhabited island along the Outer Banks.

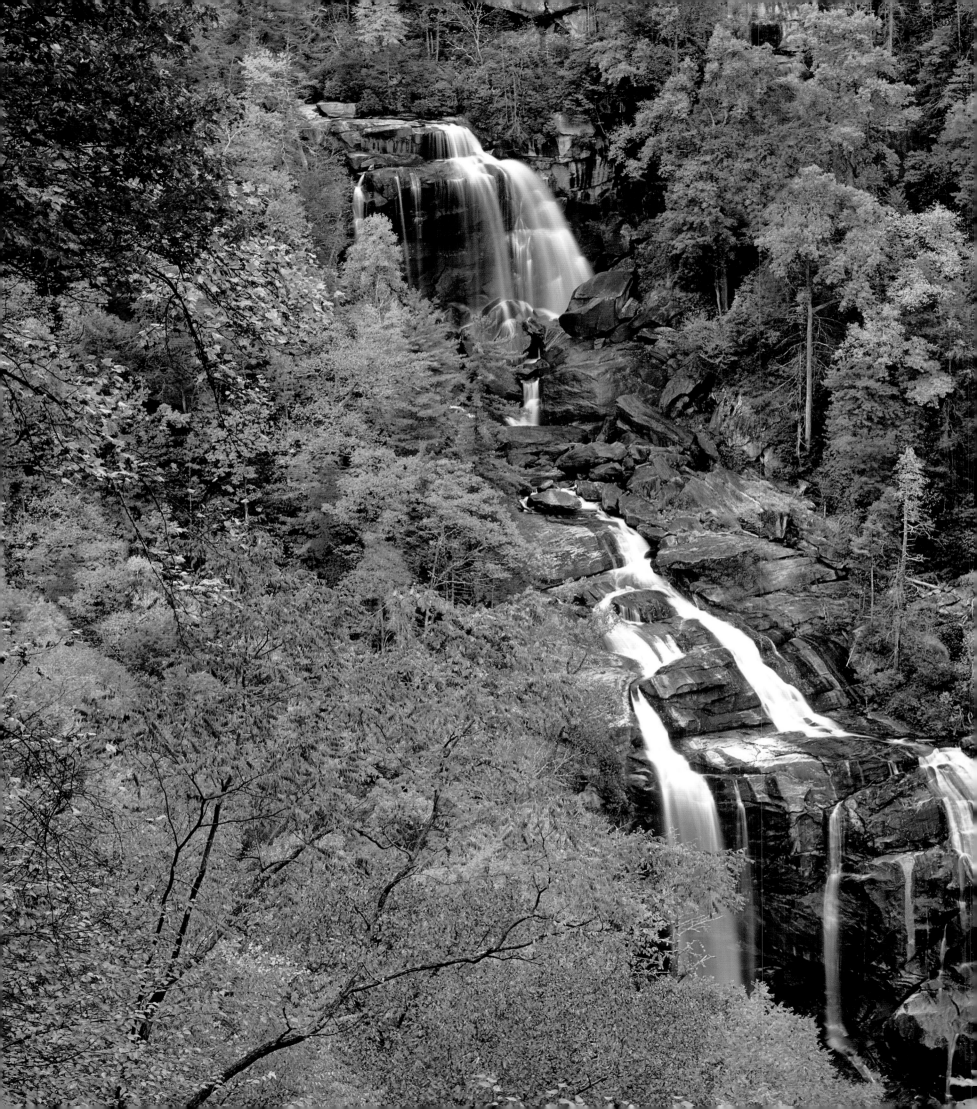

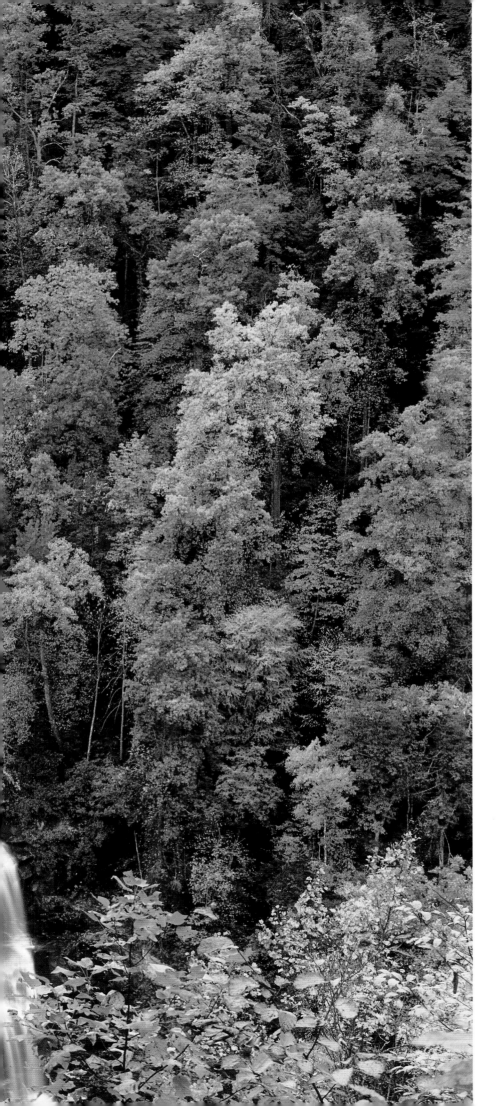

Above: Autumn leaves create a still life scene as they float on the surface of a small pond near Cashiers.

Left: Upper Whitewater Falls in Transylvania County drops 411 feet over the Blue Ridge Escarpment, making it one of the tallest waterfalls in the eastern United States.

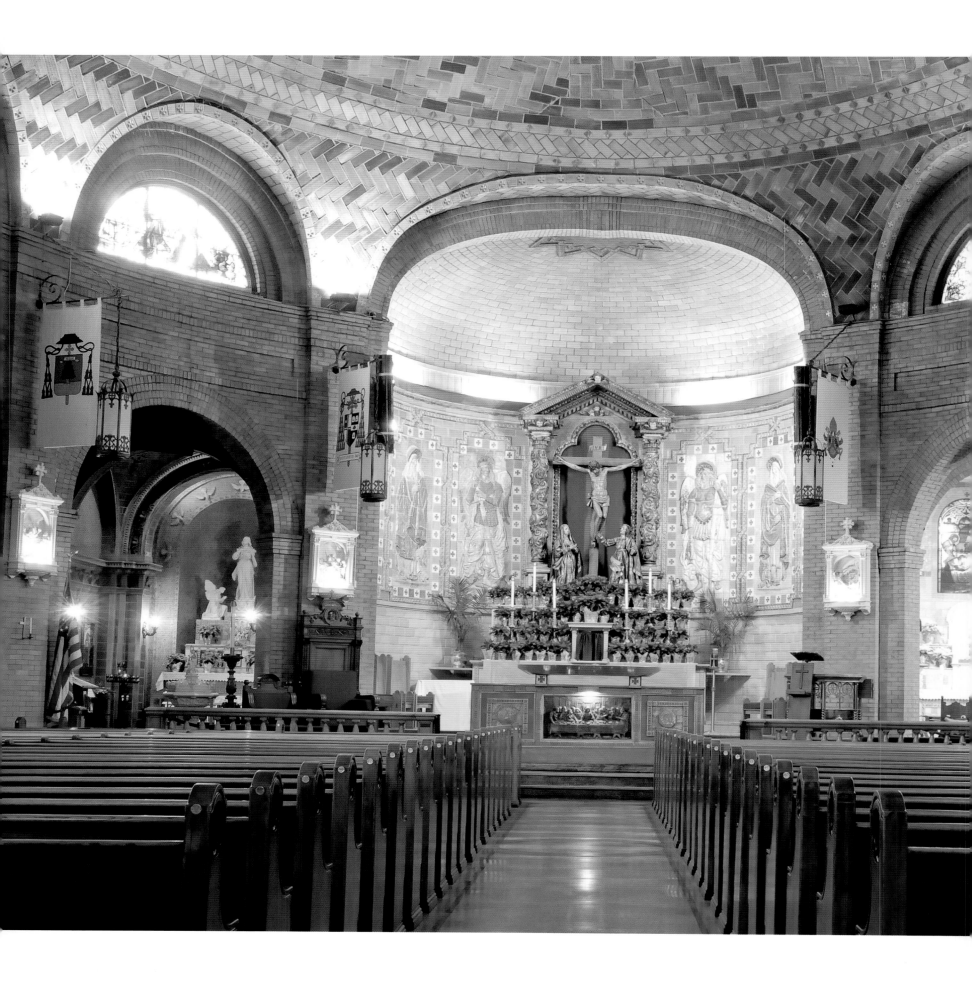

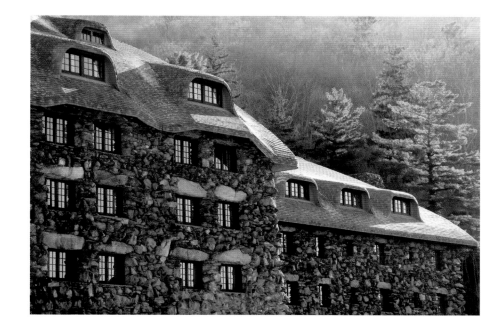

Above, top: The rustic and historic Grove Park Inn has been welcoming guests to Asheville since 1913. The original inn was constructed of local granite, including boulders weighing up to 10,000 pounds.

Above, bottom: The waters of Toxaway Falls spill over a rocky ledge surrounded by vibrant autumn color. Just a short distance upstream is Lake Toxaway, a beautiful mountain destination surrounded by vacation homes.

Left: The Basilica of Saint Lawrence is a beautiful house of worship in downtown Asheville. It was designed by Spanish architect Rafael Guastavino and completed in 1905. Its dome remains the largest unsupported dome on the continent.

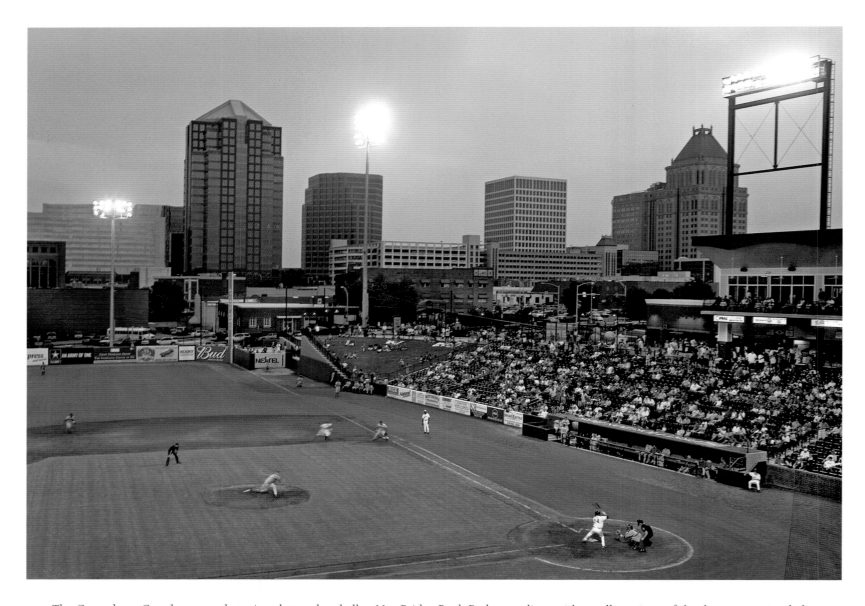

Above: The Greensboro Grasshoppers play minor league baseball at NewBridge Bank Park, a stadium with excellent views of the downtown city skyline.

Facing page: The seventeen-foot sculpture *Firebird,* by Niki de Saint Phalle, gleams with its mosaic construction of mirrored glass. *Firebird* greets visitors to Charlotte's Bechtler Museum of Modern Art, which boasts works by such artists as Picasso, Miró, and Warhol.

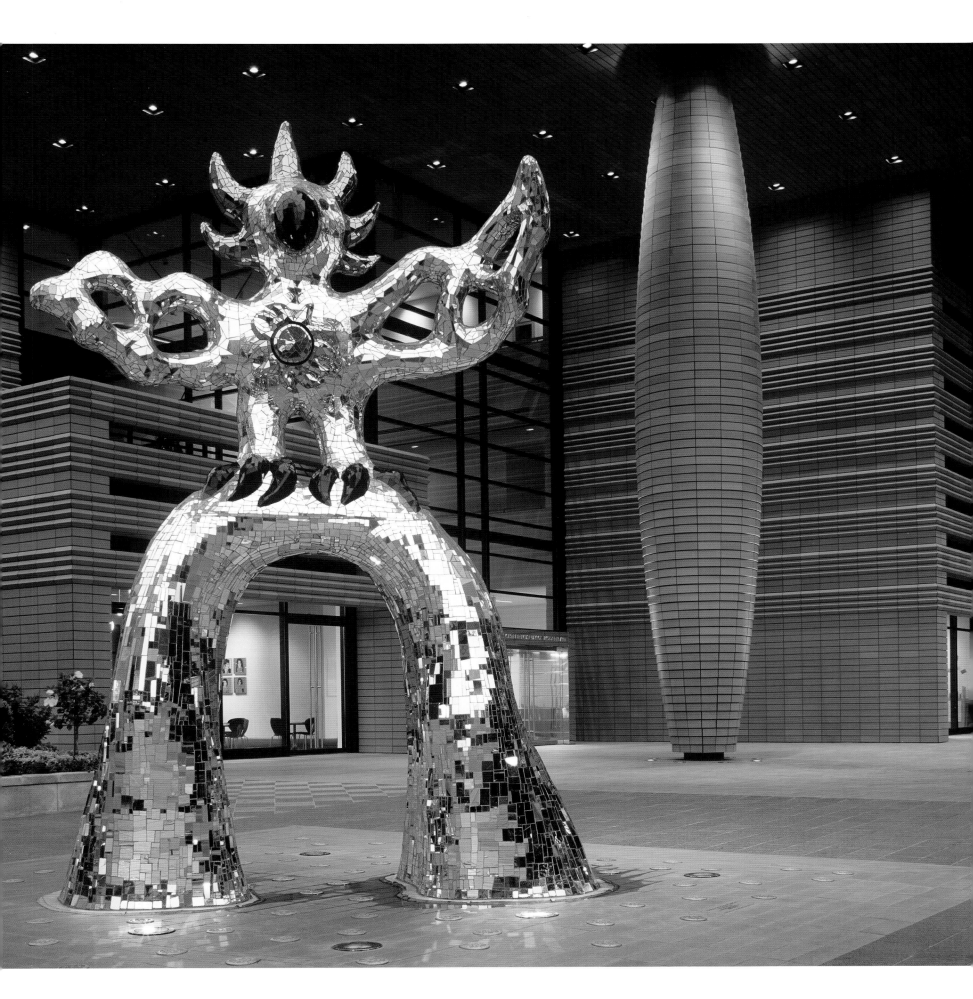

Above, top: Asheville's artistic spirit is evident in the beautiful murals that can be found all over the city. This Asheville Mural Project piece honors North Carolina's past and current Native American residents. The state has the largest Native American population in the eastern United States.

Above, bottom: Wrought iron is a classic architectural detail found in many of Wilmington's historic homes.

Right: All is quiet and still on a foggy late autumn afternoon at Highlands Nature Center.

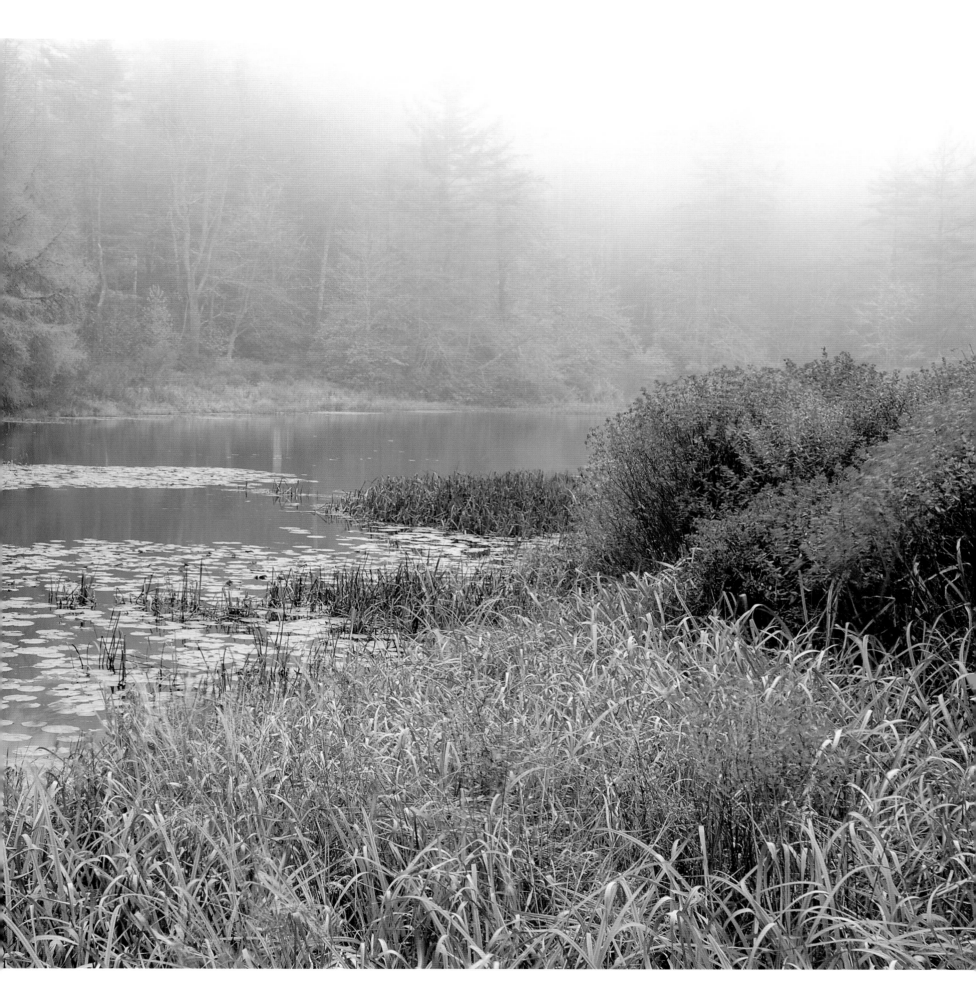

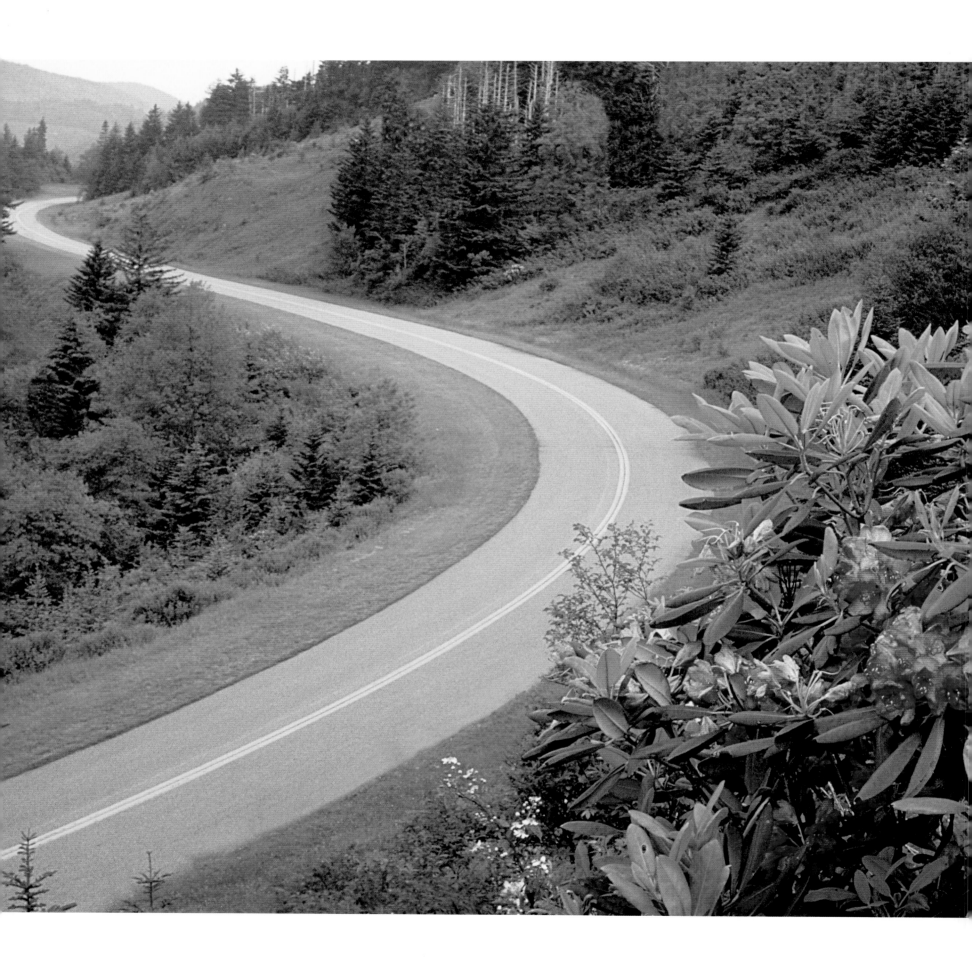

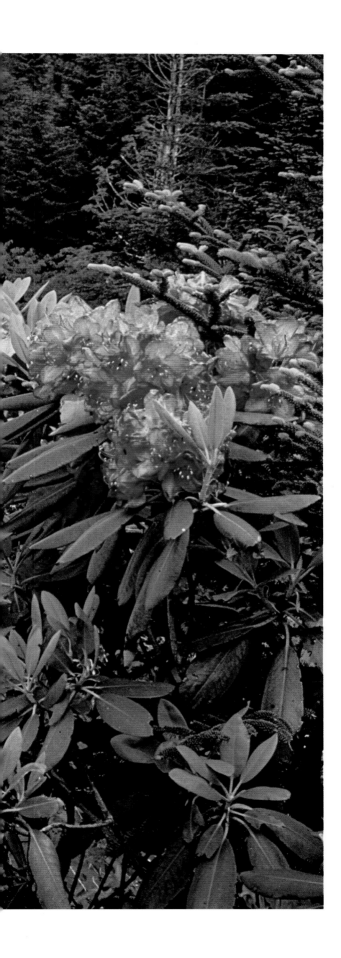

Above: Springtime azaleas are in peak form at Memorial Garden in Concord. Sallie Phifer Williamson created the garden in memory of her mother in 1930, and it is part of the 200-year-old First Presbyterian Church cemetery.

Left: The Blue Ridge Parkway twists and turns for 469 scenic miles from the edge of Great Smoky Mountains National Park northward to Shenandoah National Park in Virginia.

Right: After a spring rain, the canopy of a mountaintop forest is shrouded in mist and fog. The subtropical highland climate, found in high-altitude western North Carolina locations like this, features abundant rainfall that can exceed 100 inches per year.

Below: Mast General Store in Valle Crucis is a nostalgic North Carolina landmark where candy and a kind word are always plentiful.

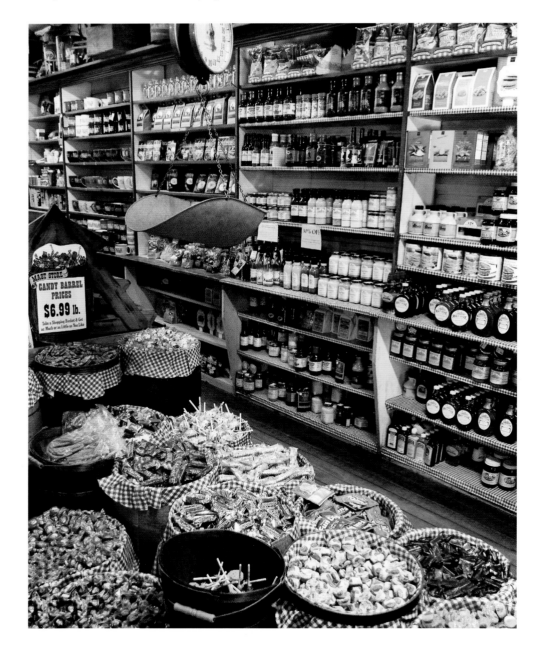

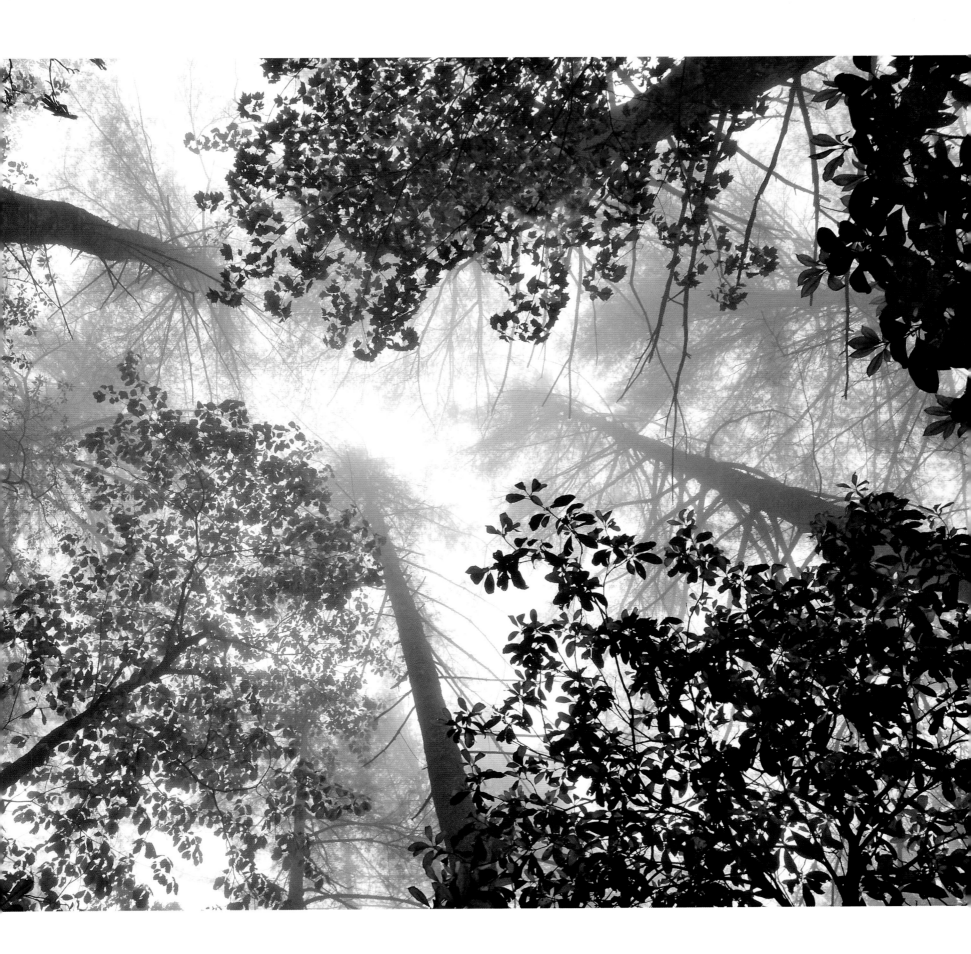

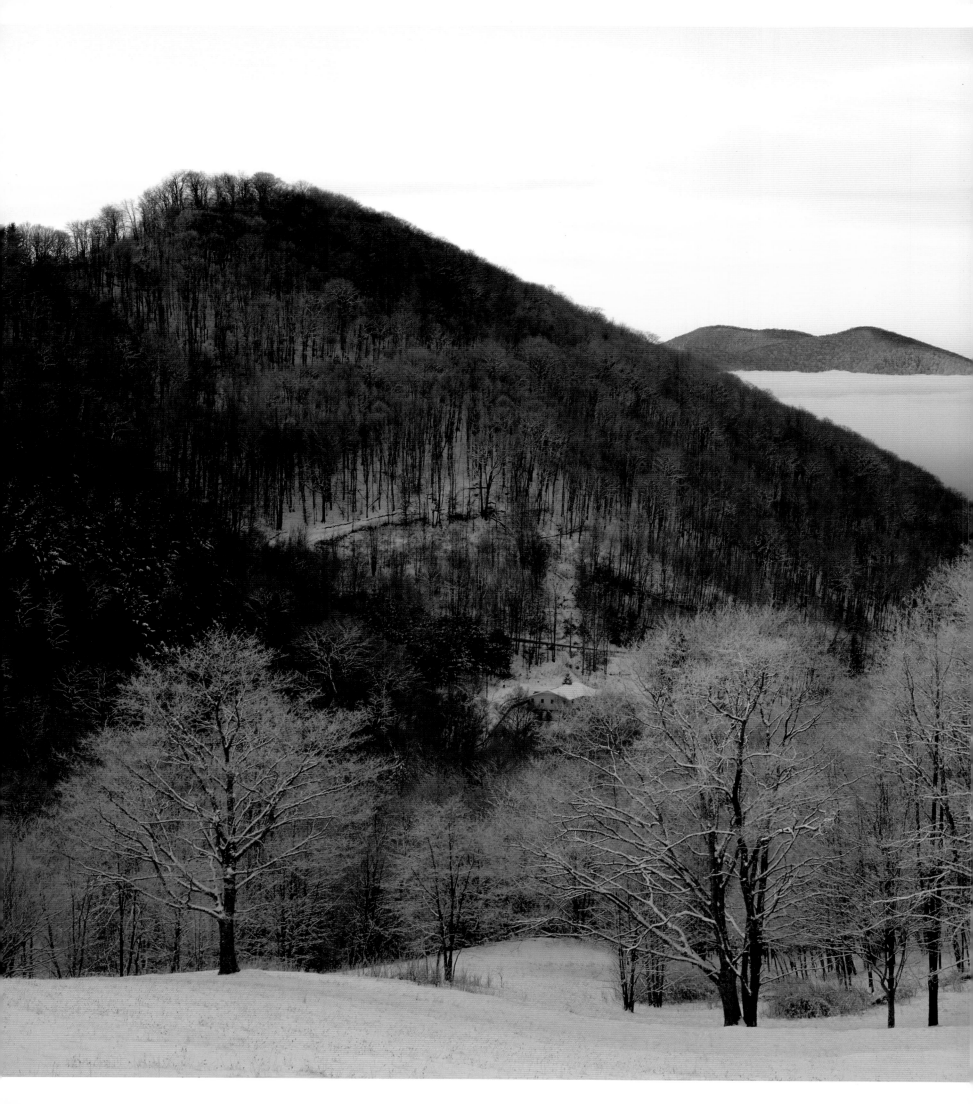

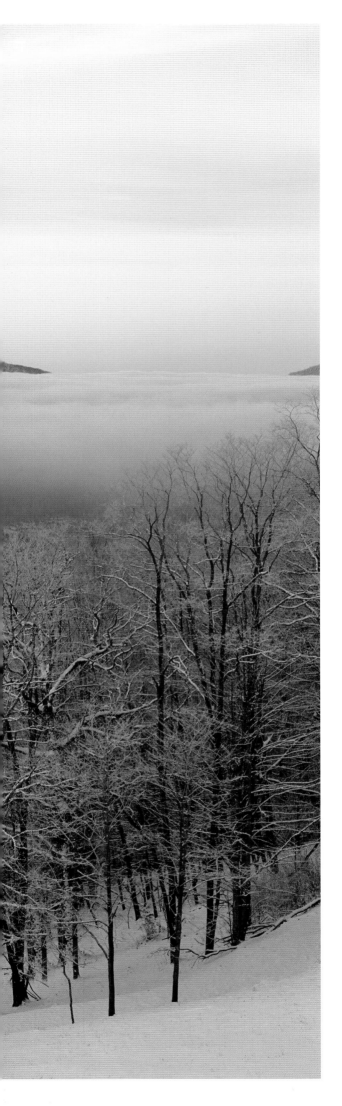

Left: Fog obscures the lowlands during a winter sunrise that brings brisk air and pinkish hues to a mountain landscape above Maggie Valley.

Below: The evening sky casts a lustrous sheen on the waters of a snowy creek near Robbinsville.

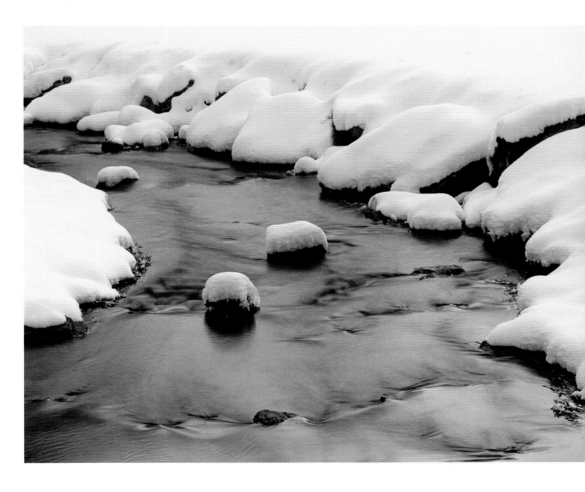

Right: The Roanoke River Lighthouse was built in 1886 and served until 1941. It was relocated to its present site on the harbor front in Edenton and has been lovingly restored.

Below: Fishing nets hang idle at day's end in Southport. In addition to enjoying fresh seafood, visitors to Southport can wander into the North Carolina Maritime Museum—one of several on the coast—to learn about fishing, naval history, and pirates such as the state's own famous outlaw, Blackbeard.

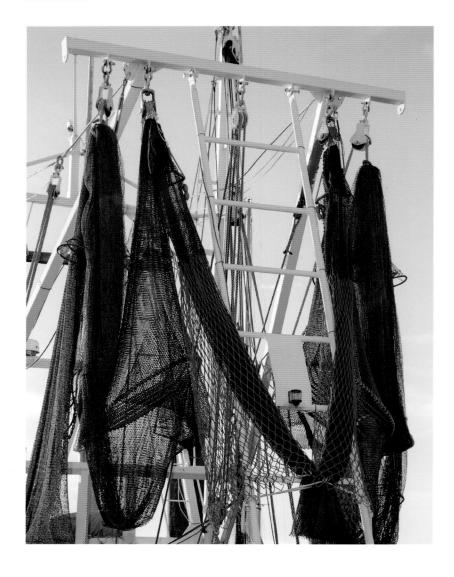

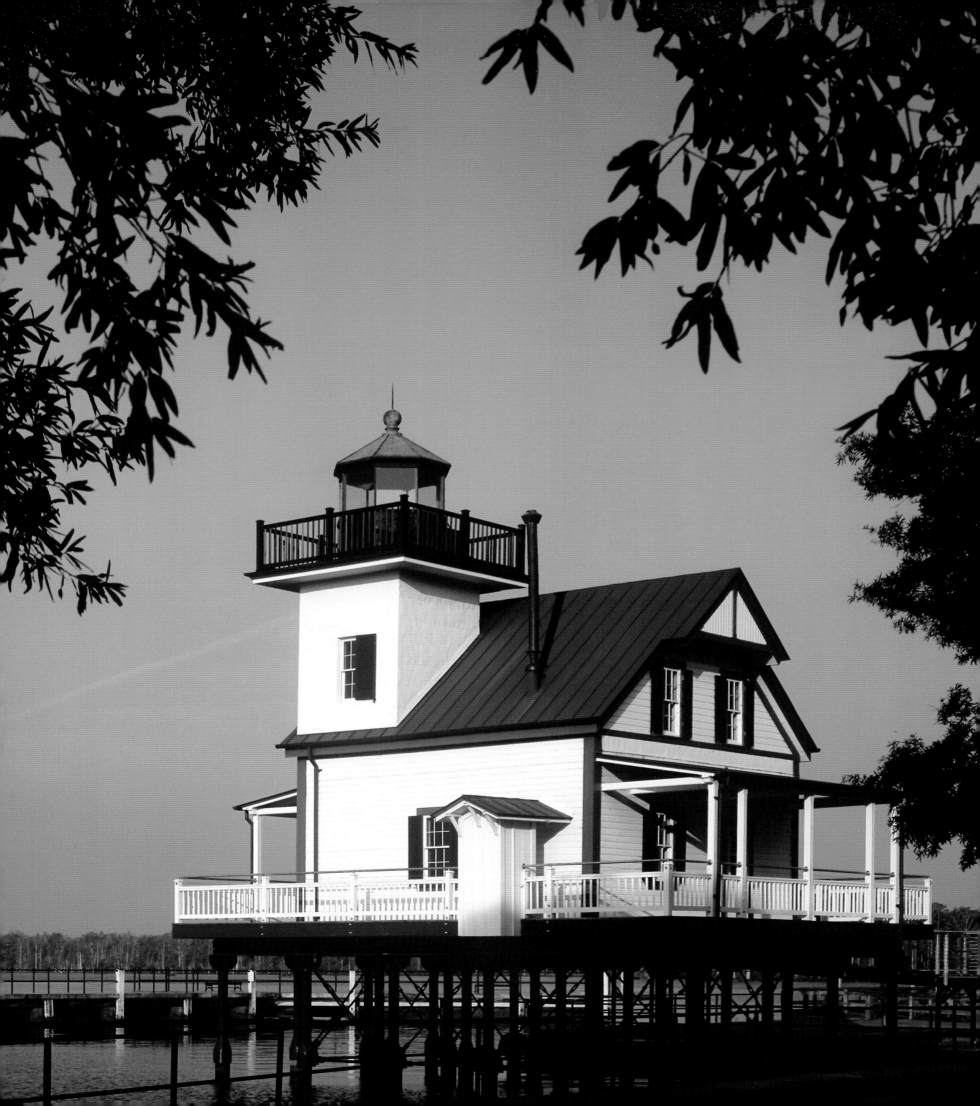

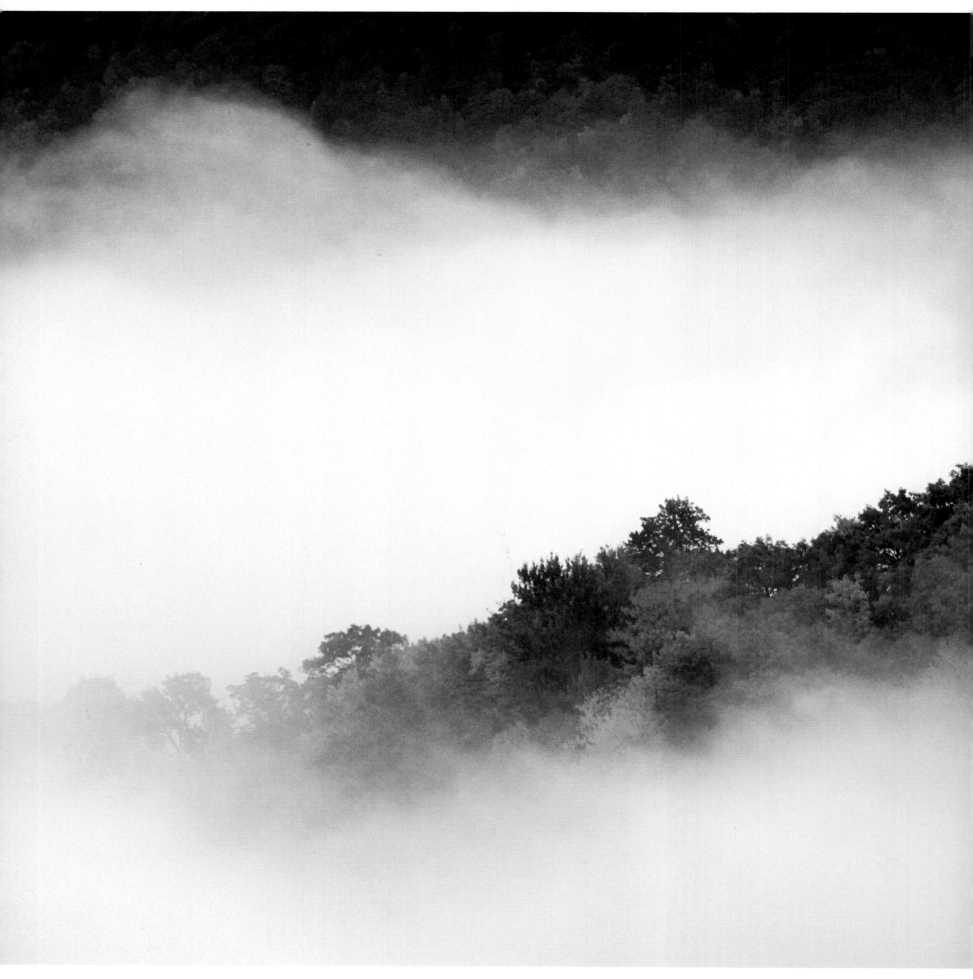

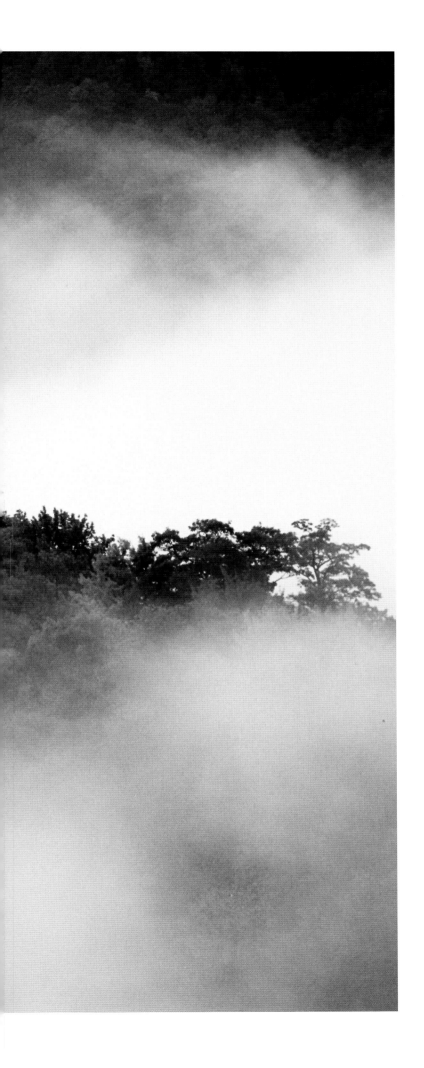

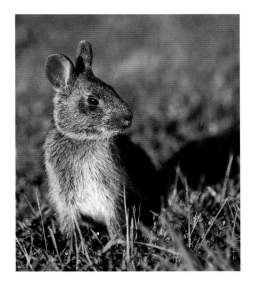

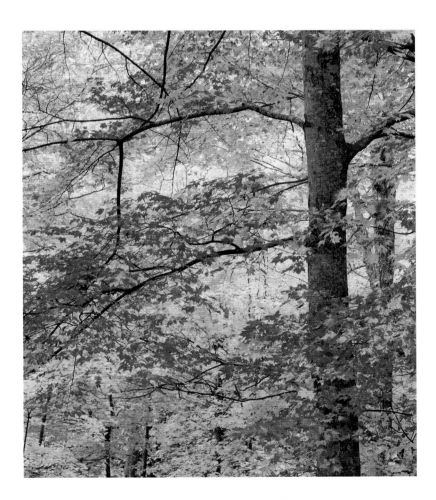

Above, top: The marsh rabbit, a short-eared cousin of the eastern cottontail, is a strong swimmer and inhabits the marshes and swamps of coastal North Carolina.

Above, bottom: Near Murphy, the rich reds and yellows of an autumn forest are saturated and vibrant after an October rain.

Left: Mist and fog part and, for an instant, reveal a high ridge near Asheville.

Following page: A splendid sunrise at Wrightsville Beach is the beginning of another unforgettable day in North Carolina.

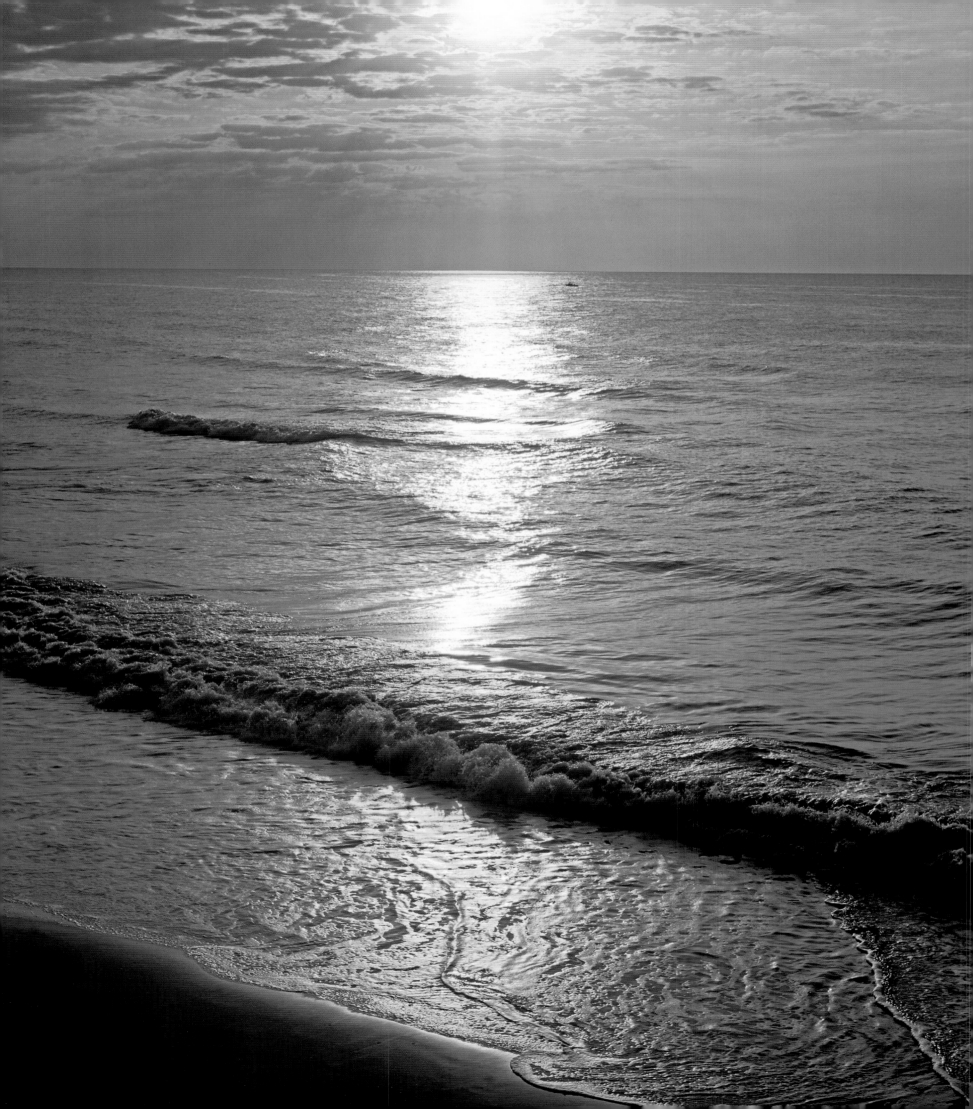